ELEGANTISSIMA

ELEGAN

PRINCETON ARCHITECTURAL PRESS
NEW YORK CITY

TISSIMA

THE DESIGN & TYPOGRAPHY OF LOUISE FILI

FOREWORD BY STEVEN HELLER

Published by Princeton Architectural Press • © 2012 Louise Fili • All rights reserved • Printed and bound in China
37 East Seventh Street
New York, N.Y. 10003
For a free catalog of books, call 1 800 759 0190 • Visit our website at www.papress.com • 15 14 13 12 4 3 2 1
First edition

No part of this book may be used or reproduced in any manner without written permission from the publisher, except in the context of reviews. Every reasonable attempt has been made to identify owners of copyright. Errors or omissions will be corrected in subsequent editions.

EDITOR
Nicola Bednarek Brower

DESIGNERS
Louise Fili, John Passafiume, and Dana Tanamachi / Louise Fili Ltd

SPECIAL THANKS TO: Bree Anne Apperley, Sara Bader, Janet Behning, Fannie Bushin, Megan Carey, Carina Cha, Andrea Chlad, Russell Fernandez, Jan Haux, Linda Lee, Diane Levinson, Jennifer Lippert, Jacob Moore, Gina Morrow, John Myers, Katharine Myers, Margaret Rogalski, Elana Schlenker, Dan Simon, Sara Stemen, Andrew Stepanian, Paul Wagner, and Joseph Weston of Princeton Architectural Press
—Kevin C. Lippert, publisher

Library of Congress Cataloging-in-Publication Data: Elegantissima : the design & typography of Louise Fili / foreword by Steven Heller.—First edition. pages cm
Includes bibliographical references and index. ISBN 978-1-61689-097-1 (hardcover : alk. paper) 1. Fili, Louise—Themes, motives. 2. Commercial art—United States—History—21st century. 3. Graphic design (Typography)—United States—History—21st century. I. Heller, Steven. II. Fili, Louise. Works. Selections. 2012.
NC999.4.F55A4 2012 741.6092—dc23 2012003147

FOREWORD
6

INTRODUCTION
8

BOOKS
16

RESTAURANTS
26

PACKAGING
76

IDENTITIES
126

DESIGNER/AUTHOR
182

POSTERS & POSTAGE
230

CREDITS
248

ACKNOWLEDGMENTS
254

FOREWORD BY STEVEN HELLER

```
                        Dear Louise,                    3/9/82
       I just wanted to tell you that I think your book and book jacket designs
                      for Pantheon are excellent! Consistently so.

       Every time I am struck by a book in our bookroom or on the in-coming table
                      it is something you've been responsible for.
                              Best regards,
                              Steve Heller
```

On March 9, 1982, when I was art director of the *New York Times Book Review*, I sent the grammatically challenged note above to Louise Fili, whom I had never met and, in fact, had never laid eyes on before. A little more than a year later we were married.

This intimate disclosure is essential, lest anyone reading this foreword to Louise's monograph presume I lack critical objectivity. Strictly speaking, at the time I wrote the note I was a genuinely objective fan of Louise's typographic elegance, visual flair, and conceptual ingenuity, as well as her keen expertise with illustration—an area I knew something about. When, for instance, I saw her jacket for Marguerite Duras's *The Lover* for the first time, I knew this exquisite piece of graphic design signaled an aesthetic transition from the so-called big-book look, characterized by large, bold type and a small illustrative vignette, to a more artfully expressionistic—indeed less overtly commercial—approach. I was right, too. Louise's work was both admired and copied by many, and her signature retro typographic style dominated mid- to late-1980s practice, prior to the postmodern/deconstruction/grunge era.

The design historian Philip B. Meggs wrote in *Print* magazine that Louise was one of "the women who saved New York," referring somewhat dramatically to her role in the mid-1980s eclectic movement that wrested design dominance from midcentury modernist austerity. Eclecticism was Louise's middle name.

I am not ashamed to admit that after seeing so many of her book jackets, I became convinced that my own design prowess was limited at best. I could never be as good a typographer—never! So, I devoted considerably more time to writing about design, eventually making

6

the transition to full-time authorship. Yet curiously, I never wrote a word about Louise. We collaborated on a dozen books and various projects over thirty years, and her work has appeared in a few of my other books. But this is the first time I have even attempted to analyze her work and place it in the historical continuum.

Obviously, Louise and I share the same design interests, including Victorian, art nouveau, art deco, futurist, and modernist typography and vintage imagery. I am simpatico with the manner in which Louise employs design history as a springboard. Where we diverge, and what is most significant about her brand of retro-centricity, is that while I enjoy (and as a designer, even practiced) pastiche, she rejects it as a crutch. The distinction may be subtle. But pastiche is about reprising past styles almost verbatim to trigger recognition (and nostalgia). What Louise does instead is build upon things passé to enliven her contemporary graphic statements—even when the result has vintage resonance.

Almost every example in this book can be unpacked to discover its influences and inspirations (and herein are detailed case studies). However, the manner in which these component parts are reassembled is uniquely Louise's. It is all too easy to add pre-cooked ingredients from archival sources, but to then transform them into designs that are at once familiar and entirely novel—well, that takes extreme discipline.

Louise's discipline was evident when she left designing book covers and jackets as her primary métier for the world of all things food related. Doing this kind of work on a daily basis made her extremely happy—I can vouch for that. Indeed, watching her design is like watching her cook: the intense attention to detail is identical. But there is one important difference: when cooking, Louise often works from recipes; when designing, she starts from scratch. Her ability to surprise herself is the design trait that keeps her work remarkably fresh—and the rest of us interested.

Freshness equals pleasure. The elegance of Louise's work routinely triggers cognitive resonance and visceral pleasure. That pleasure exists on different levels depending on the viewer. The design cognoscenti doubtless experience the joy of Louise's craft, while the average viewer might engage only with the surface conceits. But her total output—as made undeniably clear by this book—is underscored by unpretentiousness and design intelligence. Even the most decorative (the dreaded *d*-word) components are essential. Never are there superfluous afterthoughts. Beauty is in the details.

And these details define Louise's virtuosity.

INTRODUCTION

A life in letters

———✻———

I CAN NEVER, EVER FORGIVE MY PARENTS FOR HAVING THE BAD JUDGMENT TO LEAVE Italy and come to America. The final indignity was that I was born in New Jersey and had to spend the rest of my life getting as far away as possible from the Garden State. My first trip to Italy was a typographic and gastronomic epiphany: quite simply, everything looked, tasted, and sounded better in Italian.

I was sixteen when I traveled with my family for the first time to *bella Italia*. As I recall, immediately upon arriving in Milan, in the haze of jet lag and the oppressive July heat, I was struck by a billboard featuring an art nouveau rendering of a couple in a passionate embrace against an inky night sky, with just the words *Baci* and *Perugina*. I knew that *baci* meant kisses, though I didn't even know what product this advertised. It didn't matter. The woman was clearly in a swoon, and so was I. This was the pivotal moment when I fell in love all at once with Italy, type, and food. Whenever I see the iconic Baci package (though it has been ruthlessly updated over the years), it still makes me smile.

Even before I knew what graphic design was, I knew it was something that I wanted to do. This term was hardly in use at that time; it was known instead as the very unsexy *commercial art*. In the same summer that I traveled to Italy, I sent away for an Osmiroid pen advertised in the back of the *New Yorker* magazine and taught myself calligraphy; I would soon be running a relatively lucrative business making illuminated manuscripts of Bob Dylan lyrics for classmates.

I went on to attend Skidmore College, where anyone who couldn't paint was labeled "graphically oriented."

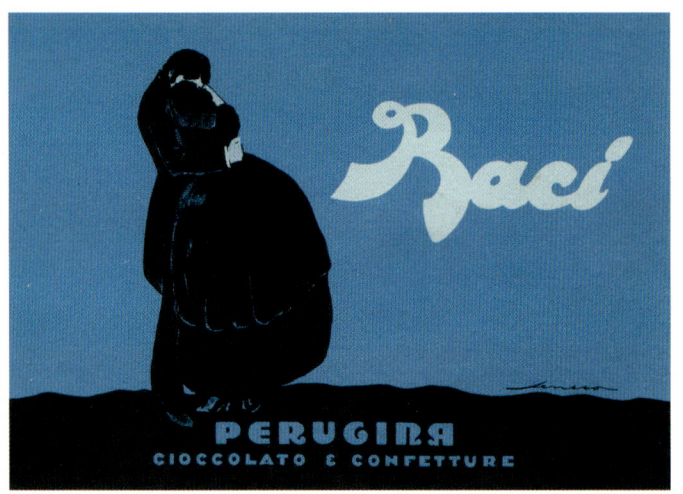

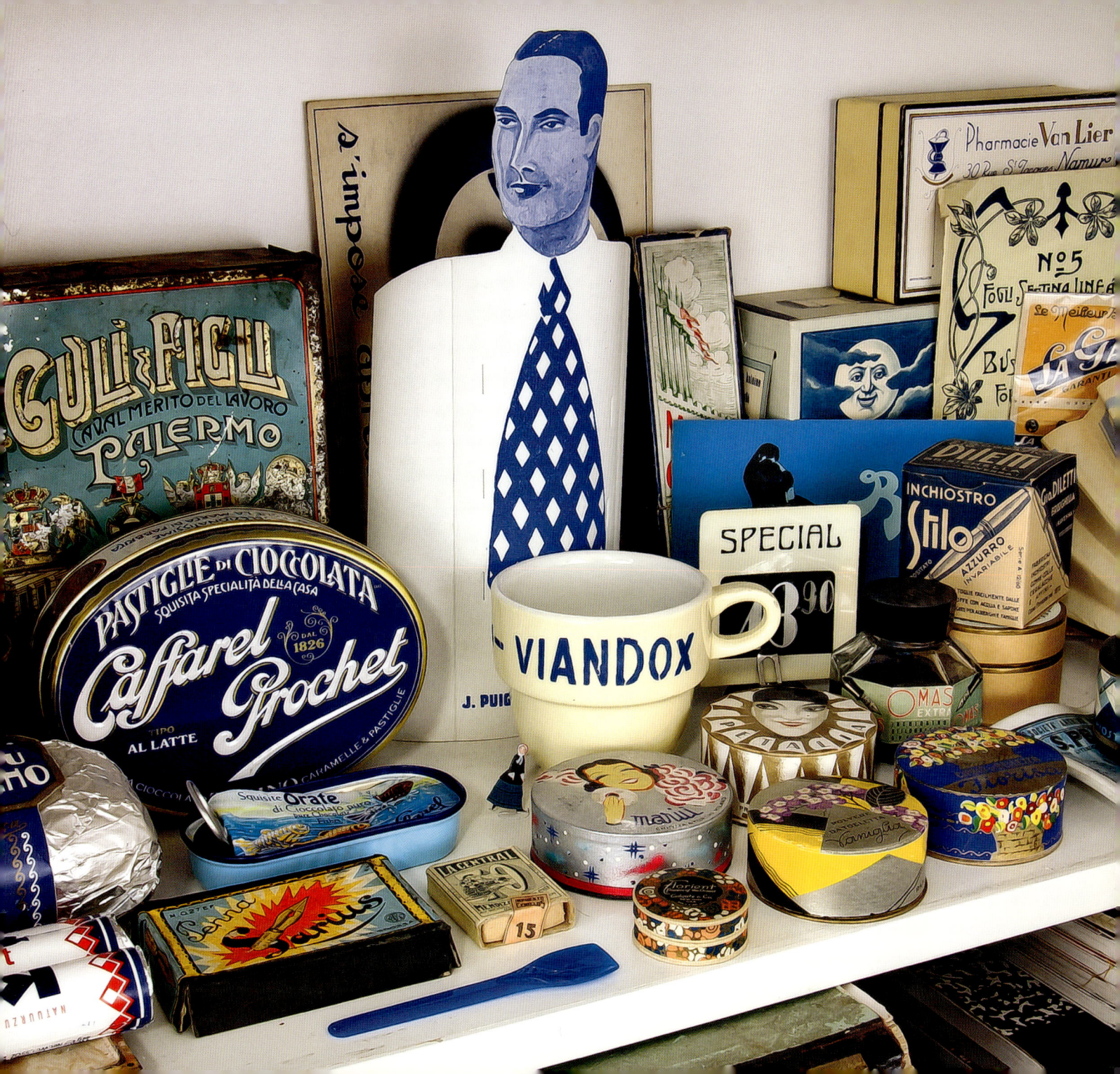

I learned typography by getting my hands dirty. I set metal type, and, predictably, my senior project was a hand-lettered Italian cookbook.

Fast-forward to New York City, where I undertook a brief semester at School of Visual Arts (SVA), an internship at the Museum of Modern Art, and a stint at a small design studio before landing at Alfred A. Knopf, where I designed illustrated books.

On my twenty-fifth birthday, I was hired as a senior designer by the legendary typographer and art director Herb Lubalin. How did I get the job? I happened to walk in on a day when someone had just given notice. (Once I started working there, I became aware that this was his modus operandi.) The Lubalin studio was a typophile's dream. The attention given to letterforms was unlike anything in my experience. And with my office located in close proximity to Herb's, I was able to continually witness his work process. Watching him sketch out a design was mesmerizing, and

with Herb Lubalin, 1977

choosing colors with him was almost comical. Herb was color-blind; we would leaf through a Pantone book together and he would say, "Let's find a nice red." Unfortunately, we would be looking at the green pages. Did I dare say something, or just let him choose? His preference for Pantone 452 was perfectly understandable; it was a totally neutral shade that allowed type to both surprint and drop out. Even though one of my reasons for joining Lubalin had been to get away from designing books, that turned out to be what I enjoyed most. This may have had something to do with one client, notorious art director Harris Lewine. Brilliant and brash, this Gauloise-smoking Humphrey Bogart doppelgänger had already been fired from half the publishing companies in New York; the other half had caught on and would have nothing to do with him. I designed jackets for him during his tenure at Harcourt Brace Jovanovich, his last employer. As an art director, Harris knew how to get the most out of designers—pointing

them in the right directions and leaving them alone. His encyclopedic grasp of design history opened new doors for me, and his take-no-prisoners approach to dealing with editors was one that I adopted (and adapted) when I later became art director of Pantheon Books. My position was unusual: although employed by Lubalin, I enjoyed relative autonomy to work directly with Harris. I was also somewhat of a renegade at the studio; while others were cramming type together as closely as possible, I had discovered something called *letterspacing*. After two years, Herb decided to relocate the studio to a converted firehouse, which would cost me my private, sun-filled office. I took this as a sign to move on.

Bob Scudellari, my former boss at Knopf/Random House, mentioned that there was a staff position opening up. I half-jokingly asked if my office would have a southern exposure. He said yes. I took the job.

Pantheon, an imprint of Random House, was distinguished by its extremely mediocre jackets. It was hard to take the books seriously, although closer inspection revealed a roster of very respected European authors. The art director whom I was about to replace took me aside, inmate-style, and somberly offered one piece of advice: "Every editor has a favorite color." After I had settled into the job, one of the editors asked me, "Why did your predecessor have to use the same vomit brown for all of my covers?"

As a colleague explained to me, "My editors have bad taste. Yours have *no* taste." I had a more-or-less blank slate, so why not make the most of it? I immersed myself in book covers. I visited bookstores obsessively, constantly asking myself how I could improve on what was current in the industry. Did a cover really need to scream to be noticed? I didn't think so. Little by little, I introduced change to every aspect of jacket design. I rejected traditional Pantone colors, opting to use paint chips from hardware stores—to the consternation of my printers. I also cut deals with the production department, like trading an extra color for an unusual paper stock. Book buyers began to take notice.

Given my Lubalin training, I automatically thought of the book jacket first in terms of typography. Without even realizing it, I was designing the title like a logo. Hand-lettering that made reference to vintage type specimens, alphabet books, and other sources allowed me to create unique type treatments. Of course, my appreciation of design history had a perfect outlet in Pantheon's Eurocentric list. I traveled to Italy and France at least twice a

year to seek new inspiration, combing flea markets and bookstores, photographing restaurant and shop signage, and collecting food packaging.

My office became a graphics test kitchen where I could experiment with a different period of type history every day. I began to find my own design voice. In addition, I had the opportunity to work with a talented group of illustrators, photographers, designers, letterers, and retouchers who helped bring my designs to life.

In my eleven years at Pantheon, I brought in just one book for publication. I am happy to say that it was this one: *Maus*, by Art Spiegelman. When the editors wrung their hands and worried, "How can we sell a comic book on the Holocaust?" I said, "It's not a comic book. It's a graphic novel." (This was a design genre that had just started to emerge.)

Two thousand book jackets later, in 1989, I opened my own studio, Louise Fili Ltd, making a conscious decision to focus on my passions for food, typography, and all things Italian. As I already had a client base from my very active freelance work for publishers, I didn't really need to look for work, but my goal was to diversify. I knew that if I tried to survive on book jackets alone, my future would be limited, so I took a chance and entered the curious world of restaurants. My first projects soon taught me that this realm was the polar opposite of publishing; I found myself dealing with clients who were just short of gangsterdom. (Allow me to illustrate: when I mentioned some difficulties I was having with another client, a restaurateur grabbed me by the shoulders, looked at me, and said, "Louise, what did you go to a lawyer for? Why didn't you come to *me*?" I realized that [a] he wasn't kidding, and [b] these are the first words uttered by Don Corleone in *The Godfather*.) This was a different world, indeed. On the other hand, I always had a table.

Do you have to be crazy to open a restaurant in New York City? No, but it can't hurt. After I began to collaborate with architectural

Pantheon Books, 1982

firms specializing in restaurants, however, I started to work with more reliable clients.

While designing restaurant identities expanded my work from paper and ink to more tactile materials, creating food packaging brought it literally into a new dimension. Once again, it was a trip to Italy that inspired me to make this transition. It all started when I uncovered a cache of vintage packaging—but more about that later.

I am very fortunate that my life and work are now one and the same. My studio is a walk-in archive of all the restaurant menus, business cards, matchbooks, and specialty food packages I have designed, as well as the many posters and flea-market finds from decades of traveling in Italy and France. Surrounded by objects that I treasure, I always feel at home, and in this environment I am routinely transported to Europe. This is a workplace where I feel just as comfortable cooking lunch for staff or clients as I do designing. In addition to limiting the scope of my work, I also tend to gravitate to smaller businesses, which affords increased creative control as well as more intimate relationships with clients. Here is a perfect example: one morning, I arrive at my studio to a phone call from Mary Kocy, my client at Rusk Renovations, who is desperately trying to get a reservation at Sarabeth's for brunch that Sunday. As it happens, Sarabeth Levine herself is due in shortly for a meeting. Then one of my assistants brings me the news that we have no hot water in the studio. I call the landlord, who informs me that it is my responsibility to call a plumber. *Call a plumber?!* Next, in walks Sarabeth. She is devastated that she cannot find someone to publish her cookbook. I call a publisher I know and make an appointment for her. The grateful Sarabeth asks how she can return the favor. "Can you make a reservation for a client of mine for Sunday brunch?" "Of course!" I call Mary with the good news. "And by the way, could you send a plumber over here?"

Louise Fili Ltd, 2000

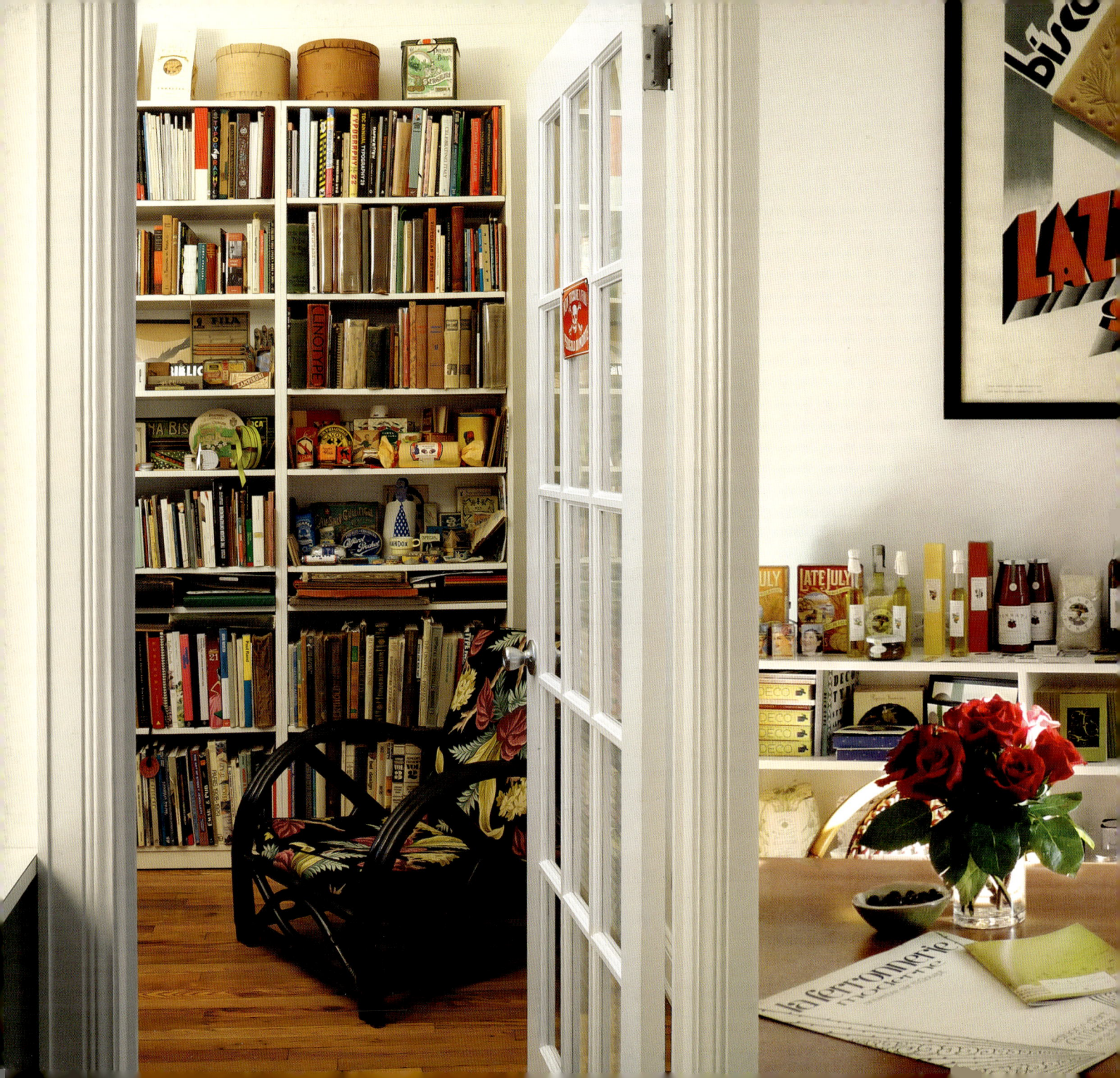

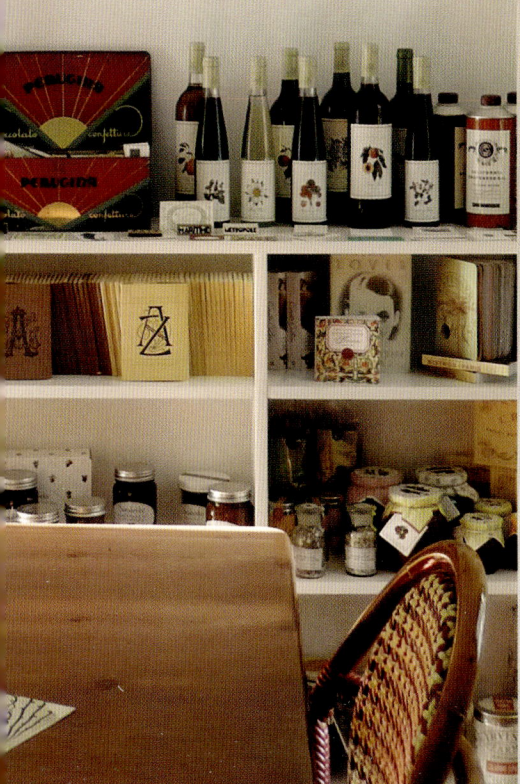
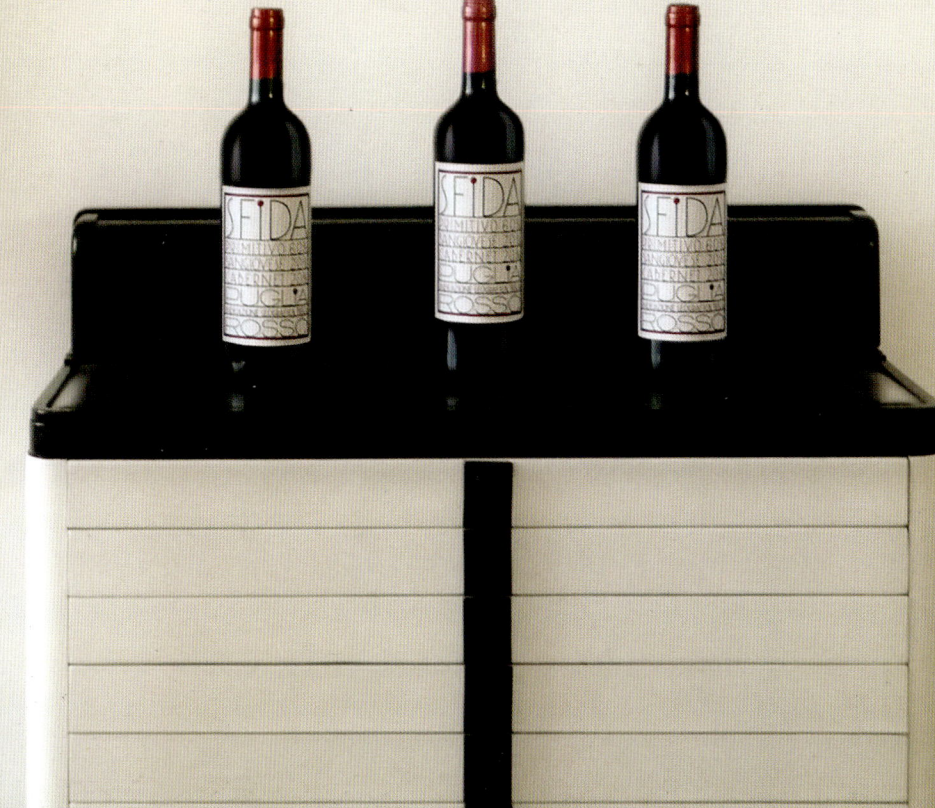

BOOKS

"WE HAVE AN ITALIAN NAZI-FASCIST HOMO-SEXUAL NOVEL THAT'S JUST PERFECT FOR you," was the odd greeting from a publisher who called to ask me to design a book jacket for his small imprint. Somehow, as art director of Pantheon Books, I had been typecast as the interpreter of sensitive (i.e., incomprehensible) foreign fiction. It was an unexpected niche, but I warmed to it. Whether designing jackets for Pantheon or freelancing for other publishers, I was determined to break away from the constraints of the big-book bestseller look that dominated jackets in the 1970s and 1980s. My jackets would be more intimate. Moreover, the designs needed to have a mnemonic allure and instant recognition, as though they were logos. Ultimately, all of the skills that I developed in book publishing became the basis for my later forays into restaurant identities and food packaging.

ROBERT CRAFT ON IGOR
ELIZABETH HARDWICK ON MARY MCCARTHY
SEAMUS HEANEY ON THOMAS FLANAGAN
Michael Ignatieff on Bruce
ALFRED KAZIN ON JOSEPH
Enrique Krauze on Octa
Robert Lowell on Randall
Dwight Macdonald on Delmore Sch
LARRY McMURTRY ON KEN
Robert Oppenheimer on Albe
Darryl Pinckney on Djuna
OLIVER SACKS ON FRANCIS
Richard Seaver on Jérôme
SUSAN SONTAG ON Pau
TATYANA TOLSTAYA ON JOSEPH
DEREK WALCOTT ON ROBERT

THE PANTHEON YEARS
Eleven years, two thousand jackets

———✳———

After the debut of Marguerite Duras's novel in 1985, the term Pantheonesque *came into use when discussing book jackets in publishing circles (and was used in both admiring and pejorative contexts).*

I WAS VERY FORTUNATE TO START MY JOB AS THE ART DIRECTOR OF Pantheon Books at a time when there was little innovation in the world of book jackets. With the same handful of designers using the same predictable formulas, few risks were being taken. Pantheon was a small, esoteric imprint at commercial Random House, and was virtually ignored in spite of their catalog of high-profile European authors such as Simone de Beauvoir and Michel Foucault. In an era of foil stamping and crass typography, I was on a mission: I believed that special-effects trickery was unnecessary. Instead, a jacket could be quietly (and alluringly) beautiful. In a series of stealth moves, I slowly introduced changes to the status quo: matte lamination, softer palettes, unusual paper stocks, unconventional illustration, and, most importantly, custom typography. The list at Pantheon continually allowed me to experiment with type from different historical periods. With the publication of *The Lover* I achieved my goal of quiet conquest. Author Marguerite Duras, although a celebrity in France, was little known to the American market, so hopes were not high for the sales of this book. With no sales or marketing department paying attention, I could design the jacket that was right for the title—subtle and ethereal, with a soft, vignetted portrait of the author at age fourteen. The hand-lettered typography complemented both the image and the dreamy style of prose. The book became a runaway bestseller (Pantheon's first since *Dr. Zhivago* in 1958), and as a result I was given more creative control. In the meantime, as it was common practice for art directors of publishing companies to freelance for one another (to supplement meager salaries), I began to work on a broader range of titles.

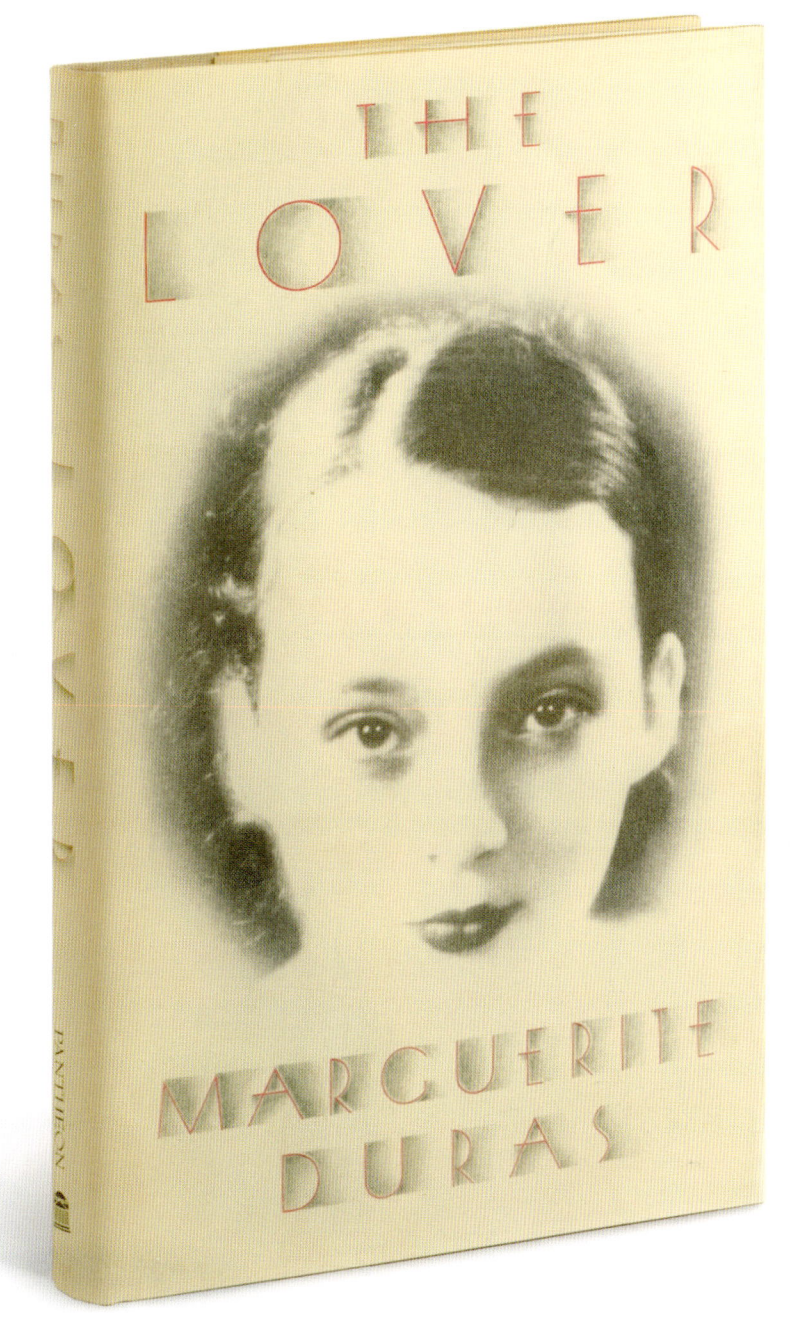

 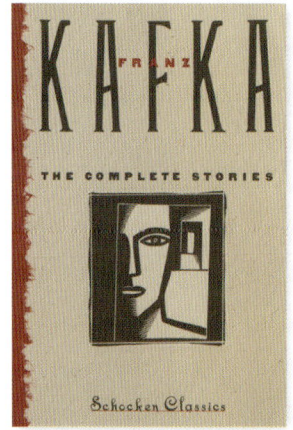 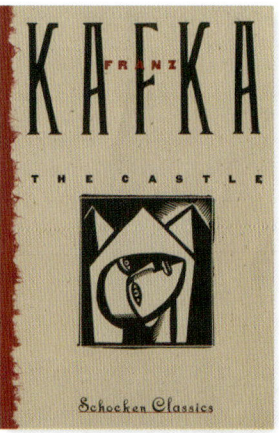

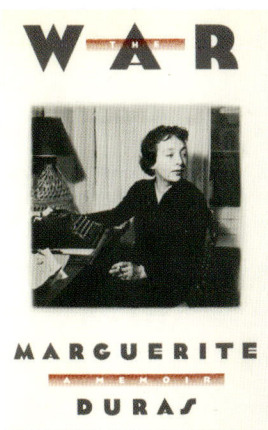

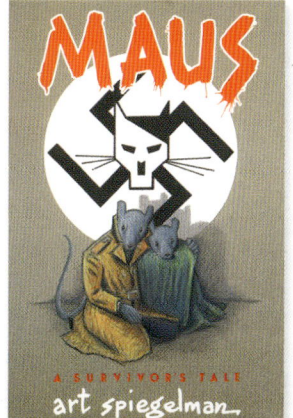
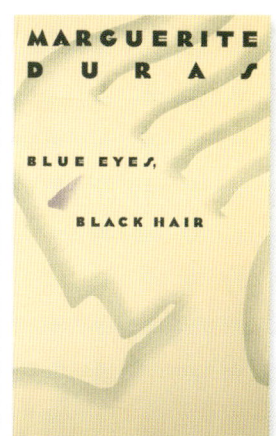

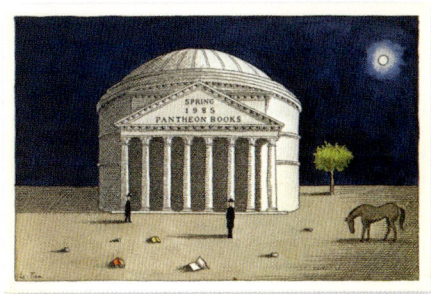

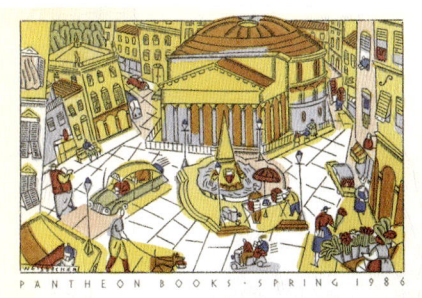
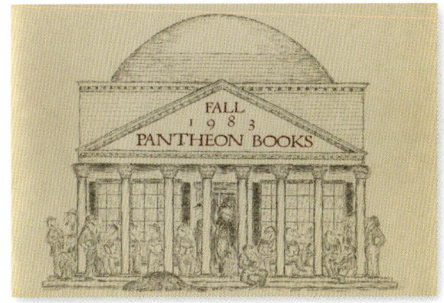
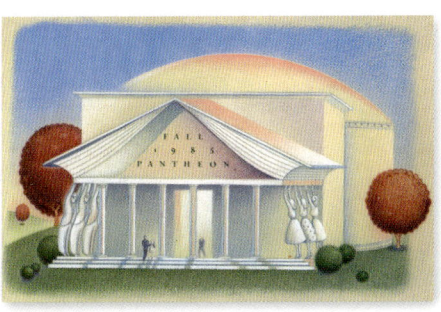
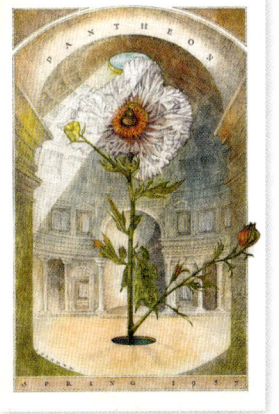
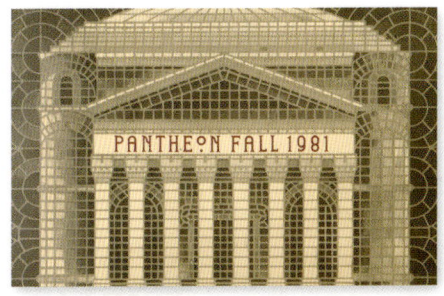

BEYOND PANTHEON

While employed by Pantheon I freelanced for many other publishers, some of whom I continued to work for once I started my studio. This allowed me to expand beyond Pantheon's very specific type of literature, and also to augment my paycheck.

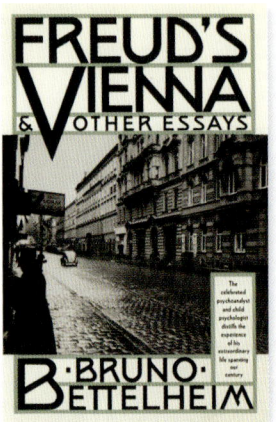 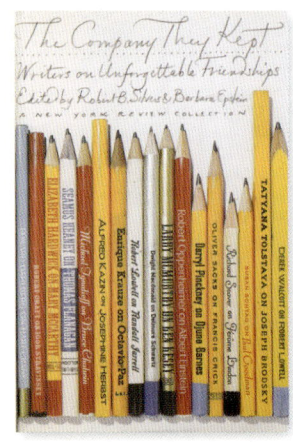

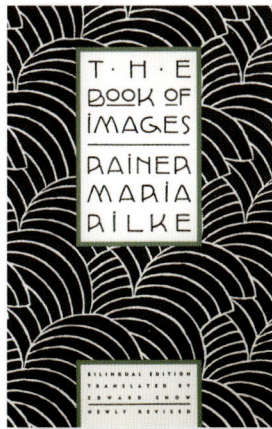

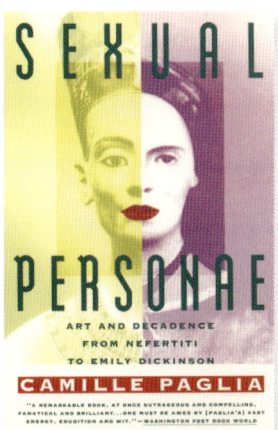

25

RESTAURANTS

I ONCE ATTEMPTED TO EXPLAIN WHAT I DO FOR A LIVING TO A FRENCHMAN. "WHAT DOES A RESTAUrant need a logo for?" he asked, dumbfounded. True, in a city like Paris, a classic bistro requires nothing more than a script neon sign; anything more designed would be suspect. In the United States, this is not the case. A logo is often the first indication of what one can expect from a restaurant—whether displayed on the door or on the home page of the website. A logo and menu must have what is best described as appetite appeal, and need to be as seductive as the food. What is the number one business most likely to fail in New York City? A restaurant, of course! At least I can always count on eating well (as long as the establishment stays afloat). If a restaurant closes, it is taken off my website. As good as an identity may have been, prospective clients do not want to visit a graveyard of their peers.

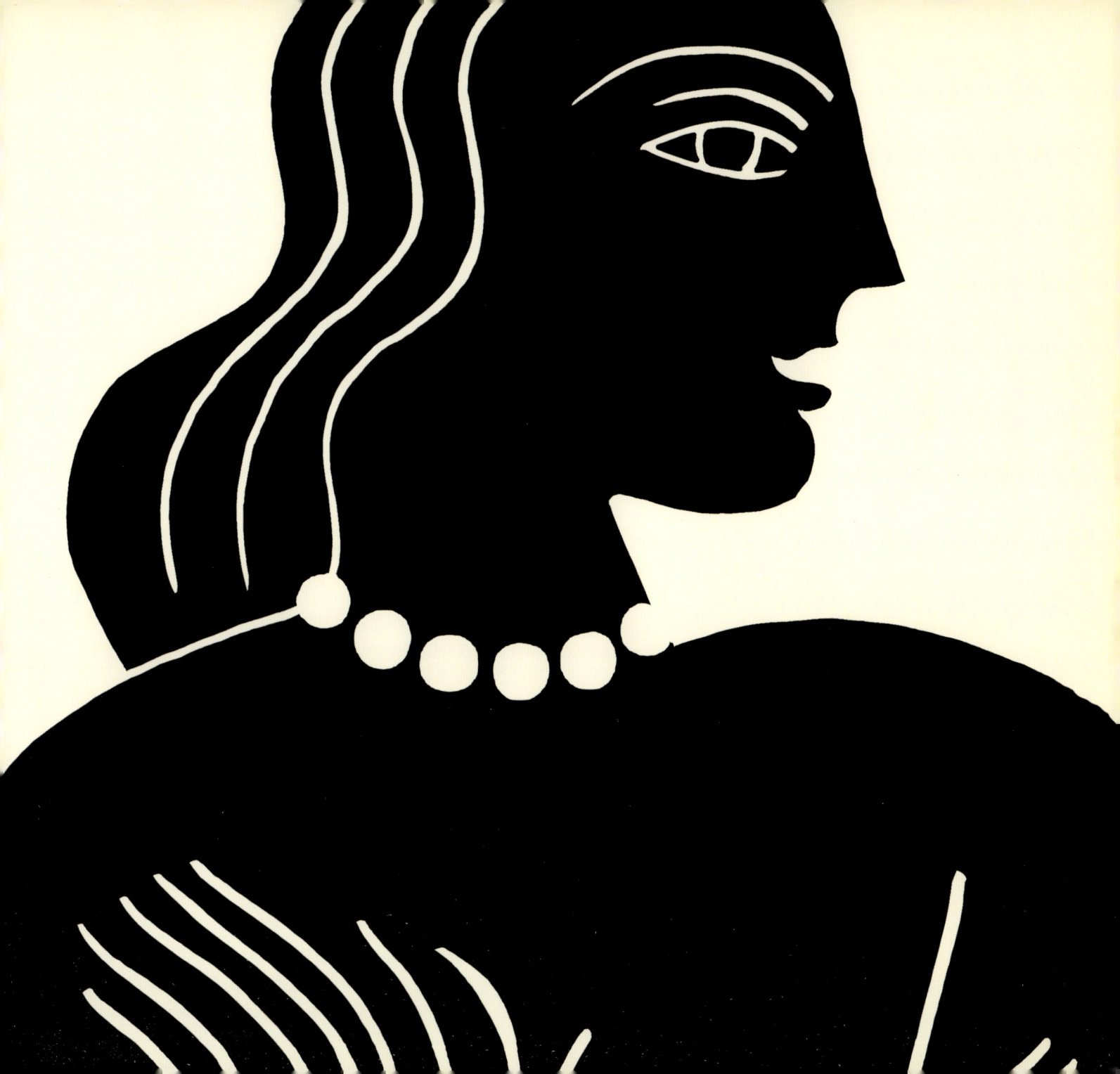

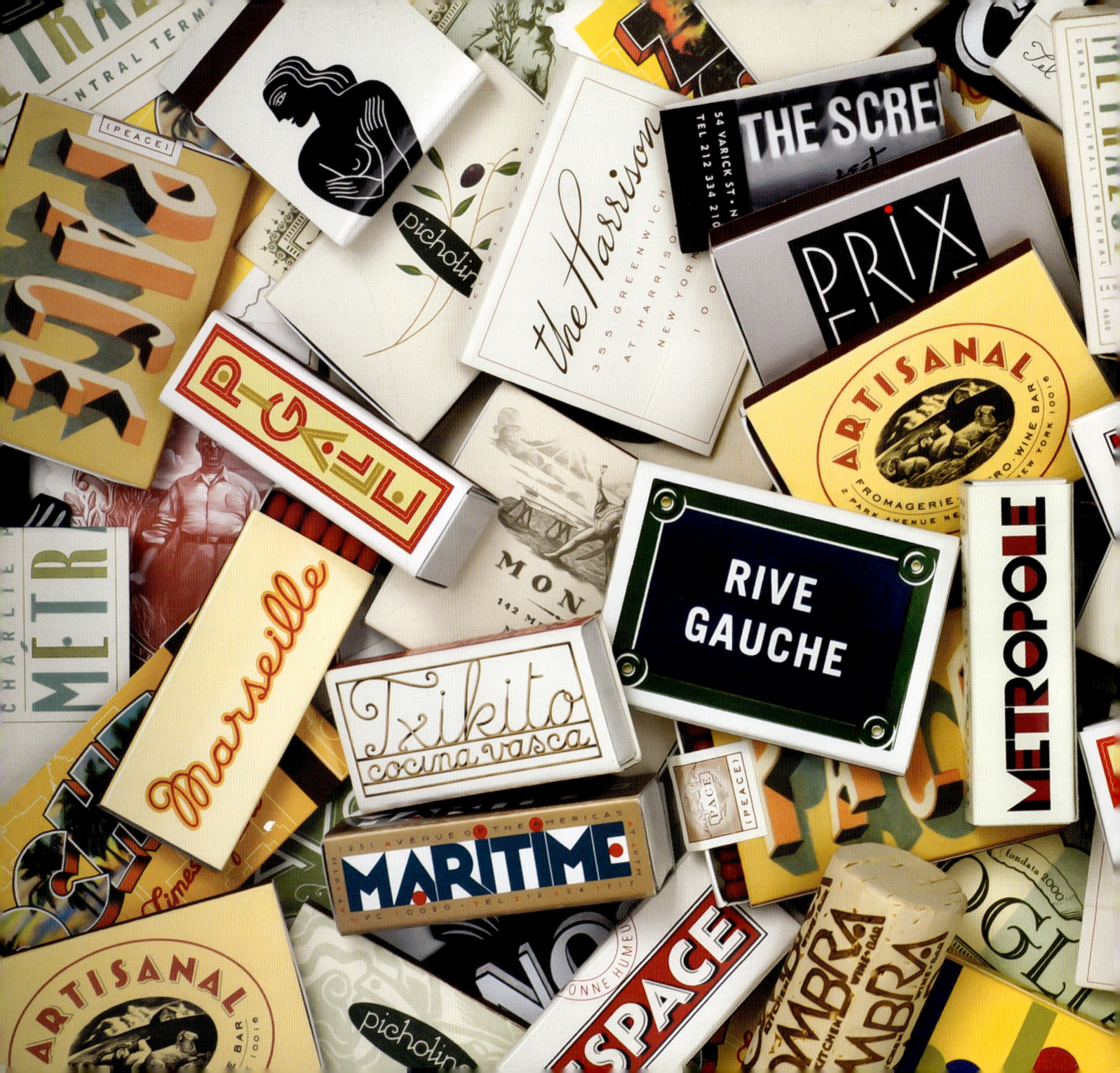

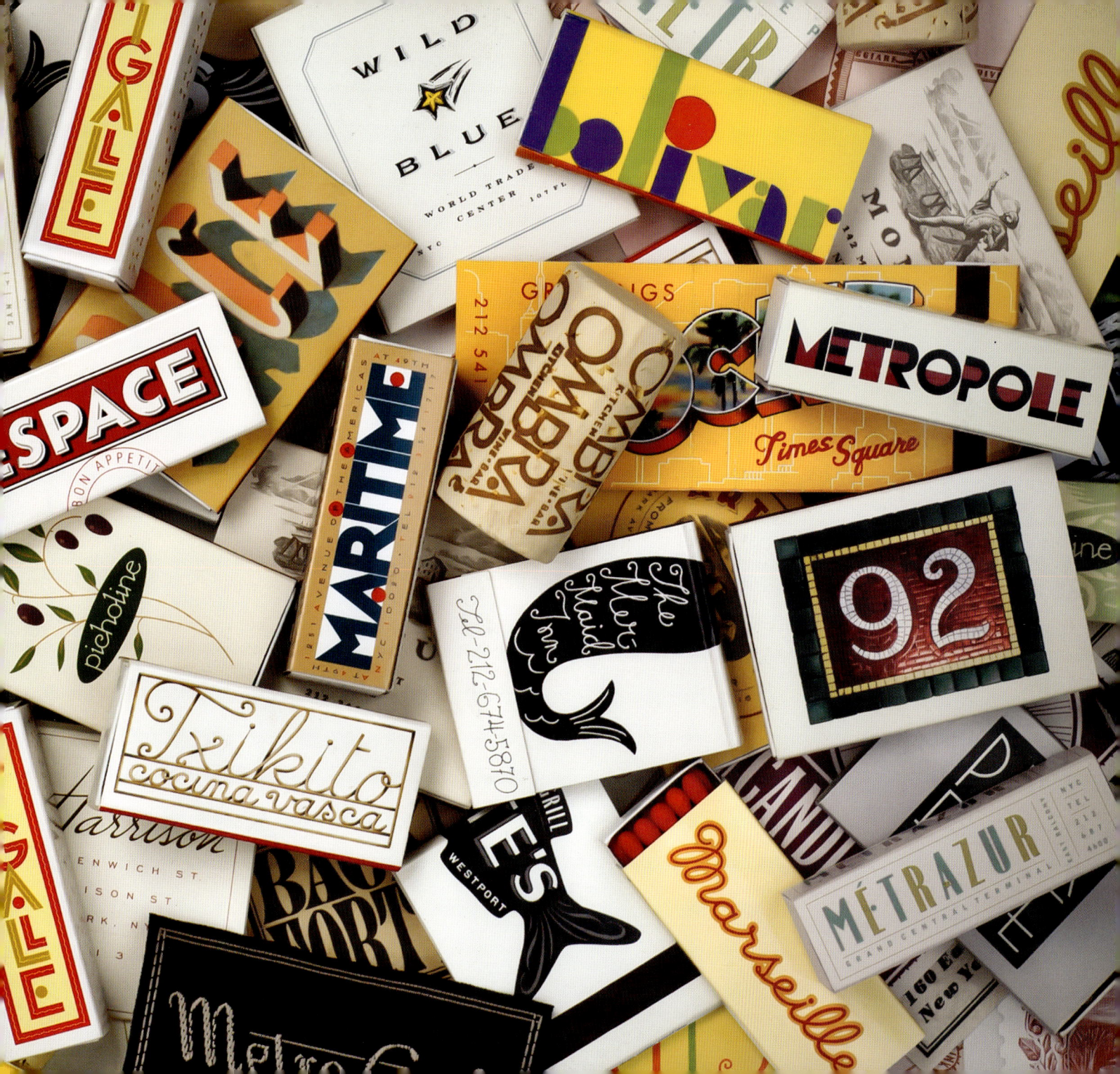

PICHOLINE
Visualizing the unpronounceable

---※---

Even though Adonis is an American typeface, it has the qualities of French hand-lettered, upright scripts that were frequently found in 1930s packaging and advertising.

IMAGINE A RESTAURANT WITH A NAME THAT NO ONE CAN PRONOUNCE, spell, or remember. How would anyone ever find it? To make things even worse, Picholine, a French-Mediterranean restaurant located steps from Lincoln Center, opened in 1993, in the pre-Google era. The logo needed to be a visual mnemonic to help people say it, remember it, and somehow find their way back there.

Since picholine is a type of olive, the name was placed in a panel of the appropriate color and shape. The hand-lettered logotype was based on Adonis, a 1930s typeface that I used to have typeset in hot metal. Fortunately, I found most of the letters I required on type proofs that I had saved in my archive; the logo was pieced together and then redrawn.

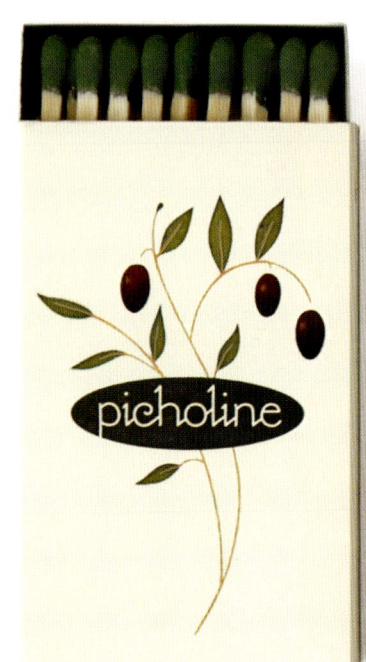

The original menu had a rustic sensibility and was bound with a fragrant rosemary branch. However, soon after the *New York Times* awarded Picholine a prestigious third star, everything was upgraded—from the linens to the glassware to the china. I commissioned a rendering of the namesake olive, which appeared on the new Limoges place settings as well as the menus, business cards, matches, napkins, and uniforms, all of which had to match. In fact, I had to carefully pack one of the dinner plates and have it shipped overnight to my printer in Vermont so that he could color-correct the menu.

Nearly two decades old, and after yet another interior-design makeover, Picholine is still flourishing with the same logo. One can only hope that the name now rolls off the tongue just a little more easily.

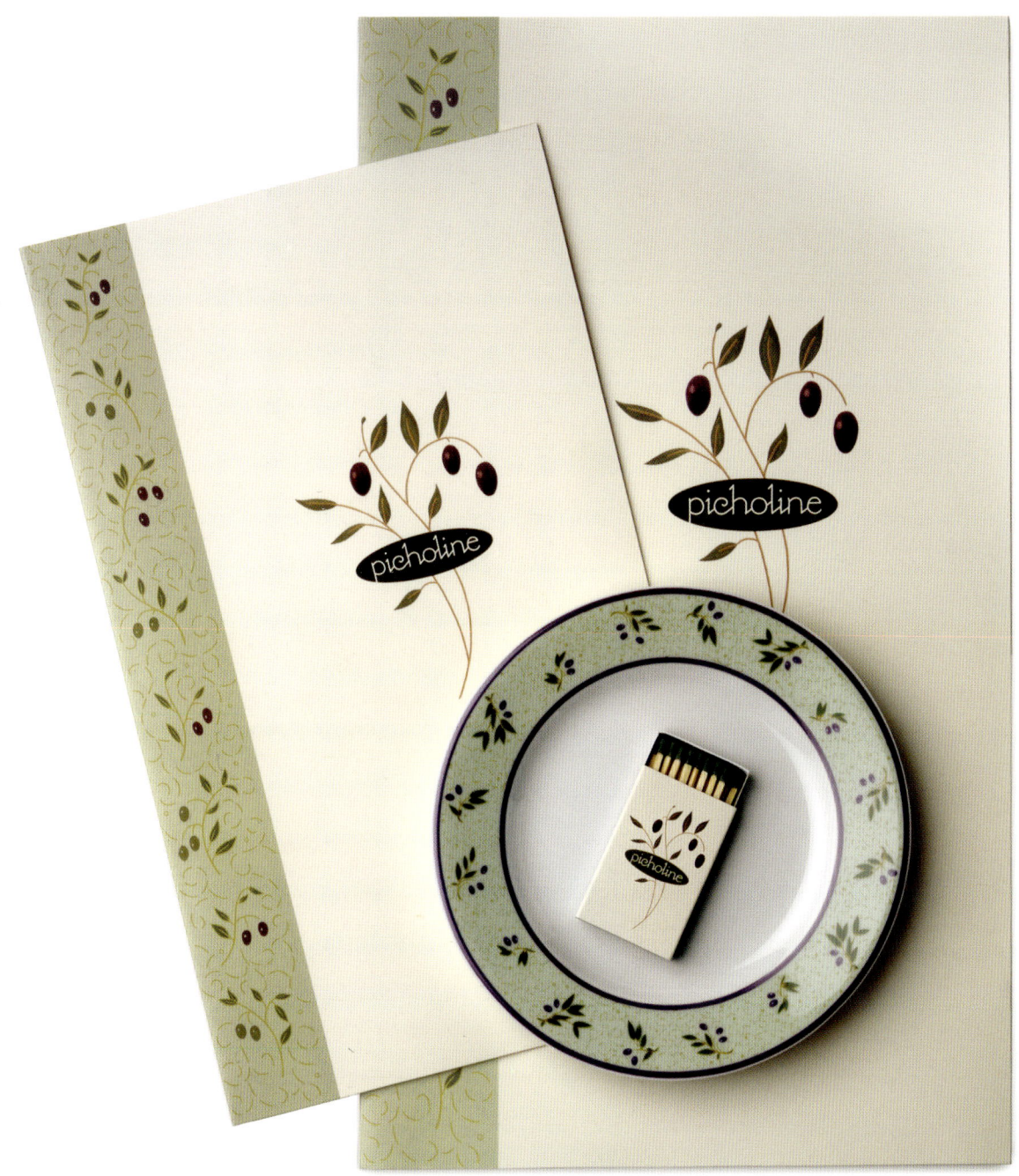

THE PINK DOOR

Dinner and a tarot-card reading

❖

I first met Pink Door owner Jackie Roberts in Florence thirty years ago, when she had fantasies of being a graphic designer and I thought it would be fun to own a restaurant. Fortunately for both of us, we each chose the correct path.

THE UNEXPECTED IS THE NORM AT THE PINK DOOR, SEATTLE'S most beloved and eclectic Italian restaurant, where on any given night an accordion player, juggler, fortune-teller, or mezzo-soprano might arrive between the *antipasto* and *primo piatto*. And did I mention the trapeze in the main dining room?

The graphic identity for this restaurant needed to echo its unique personality. The lively pattern, inspired by Italian *pasticceria* papers from the 1930s, appears on the business card, menus, wine list, and wine label, inviting guests to *festeggiare, cantare, ballare, divertirsi, sognare* (celebrate, sing, dance, have a good time, dream), and, of course, *mangiare* (eat).

The hand-lettered typography for the logo was derived from metal typefaces from both sides of the Atlantic. The business card was printed in letterpress on duplexed laid stock in copper metallic ink, for extra appetite appeal. *Proprietaria* Jacquelina di Roberto (a.k.a. Jackie Roberts), a longtime friend, is very particular about her shade of pink: not too pink, not too peachy. When we learned that the just-right shade of paper stock for the business cards was about to be discontinued, Jackie stockpiled enough for the next several decades. If you ever come across any Strathmore Pastelle pink in cover weight, please contact her immediately.

Still going strong after nearly thirty years of unflagging success, the Pink Door is one of my favorite places for dinner (and a tarot-card reading). Of course, don't bother to look for a sign for this restaurant at the Pike Place Market. You'll find it behind an unmarked pink door.

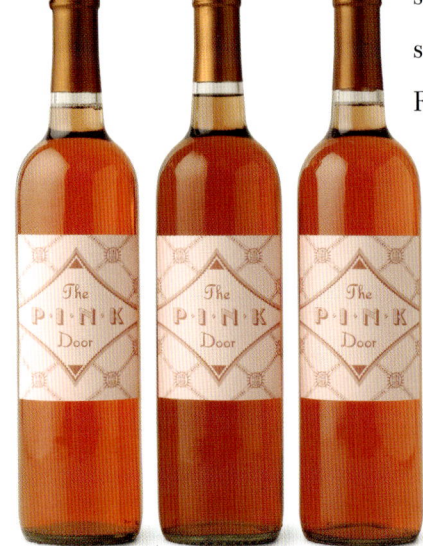

32

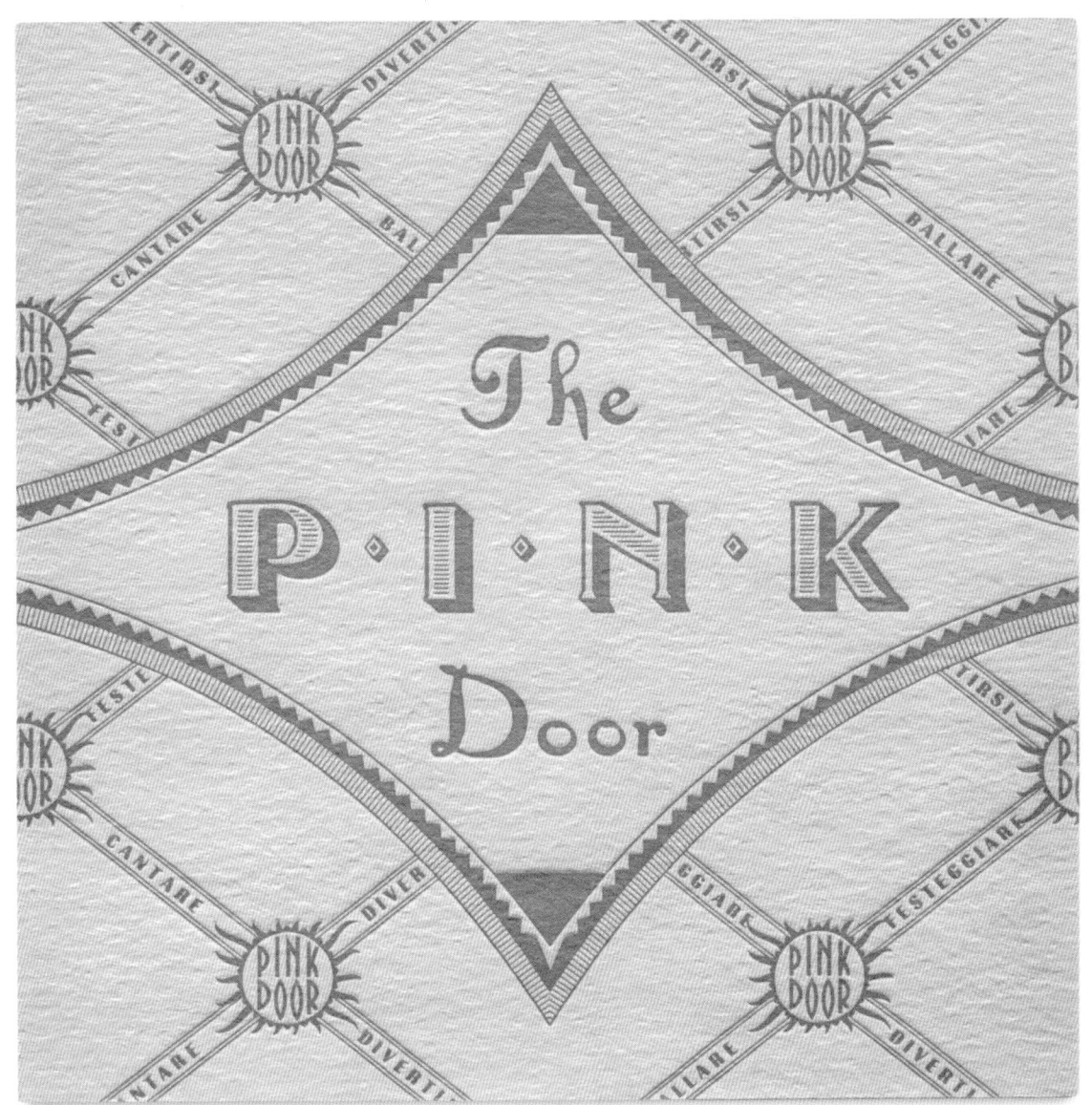

MARSEILLE

Bringing Paris to Ninth Avenue

———— ✻ ————

Whenever I walk around Paris, I see elements of the neon signs that I researched for the Marseille logo. Coming across one of these is like paying a visit to an old friend.

For years, I have been obsessively photographing shop and restaurant signage in Europe, particularly in France and Italy. Whenever I travel, I make a point of going to a city I have never visited before, just to document the signs. (This also requires walking up and down absolutely *every* street, since the best signs are inevitably found at the most obscure dead ends.) I keep the photographs arranged by city, in binders on a dedicated shelf in my studio, where they serve as a frequent source of inspiration. Few things make me happier than to leaf through these images, especially given that many of these signs—even the most iconic—have long since disappeared.

Marseille, a bistro in New York's theater district, was begging for a classic French neon script logotype. I scheduled a meeting in my studio with the owner, the architect, and the sign maker, where we pored over my endless volumes of Parisian cafe signs. Once we decided on the particular technique of using double-channel neon, I set to work sketching out letters based on some of my photographs. The sketches were then transformed into vector art for the sign maker, who would fabricate the neon sign, which would then be installed and photographed. The illuminated sign would become the logo. (Or so I thought.)

Alas, the restaurant business is like none other on this planet. The sign could not be made in time for the restaurant opening, so the digital art itself became the logo. I wanted to make the menus as graphic as possible, so the (very long) name was divided into random sections for each application. Eventually, the neon sign was completed and looked just as it was meant to. The final result could easily have joined the other photos in my Paris binders.

35

① *A selection of pictures of neon script signs from Parisian restaurants and cafes that I have been documenting over the course of many years. These were spread out on my conference table and studied in detail with the owner, the architect, and the sign maker.*

①

A Jean Nicot

Le Conti

Les Mouettes

La Coupole

Brasserie

Le Primerose

2 *The sign photos are arranged by city and archived in a series of well-thumbed binders on a shelf in my office.* **3** *The final result, on the corner of West Forty-fourth Street and Ninth Avenue, could almost pass for Parisian signage.*

MONZÙ

Omaggio a Sicilia

———✳———

The type used for the logo was based on a font that appeared in a popular 1920s Italian magazine. The original name of the typeface was Ohio; it was designed in Germany in 1924, but to me it looks quintessentially Italian.

THE TERM *MONZÙ* IS THE SICILIAN BASTARDIZATION OF THE WORD *monsieur*. A *monzù* was a private, French-trained chef for aristocratic families in early nineteenth-century Italy. I was already familiar with the *trinacria*, the symbol of Sicily (a Medusa head sprouting three legs), but I had not been aware that it referred to Sicily's triangular shape. Always delighted to find a new excuse to taper type to a point, I based the design for this Mediterranean restaurant on an image from my collection, which I later had redrawn by an illustrator. Whenever I present logo options to a client, I always develop my favorite a bit further to help shepherd it through. For this meeting, I mounted a business card showing my preferred option on a heavy cover stock and cut it out with a photographer's paper cutter (once used to create the deckle edge of snapshots). After decades in the logo business, I have come to the realization that every client wants to be taught just a little something. Not a lot, mind you—just a little. At the presentation, I shared the story about the *trinacria*, which the clients devoured. Naturally, this was the option that was approved. As I left the meeting, I overheard one of the partners as he showed the card to his assistant, explaining in a professorial tone, "and that's because Sicily is a triangular island."

The business cards were printed in letterpress and die-cut to approximate a deckle edge. (Some guests wondered how it would fit into a Rolodex.) The cards were also tipped by hand onto the menus, and the colored stock was matte laminated to be impervious to the restaurant's free-flowing olive oil.

39

UNION PACIFIC
A new take on Asian

———✳———

When negotiating the fee for Union Pacific, I finally gave in to the client's pressure for a discount, for my own secret reason: I was working on the second volume of Logos A to Z *(page 198) and was desperate to design a logo beginning with the letter* U.

Union Pacific was an intriguing new assignment. Upon hearing the name for the first time, I instantly conjured up 1920s posters from the Union Pacific Railroad. But, no—the name had nothing to do with trains. Instead, it was a reference to the restaurant's relative proximity to Union Square and to its neo-Asian cuisine. I knew immediately that in order to keep the eating public from having the same misconception, I would compose the type vertically, in a nod to Eastern characters. Eve, an elegant typeface from the early 1900s that has the unique capacity to adapt to almost any occasion, worked perfectly. The background pattern was inspired by the Wiener Werkstätte; I had once used it for the cover of a book of poems by Rainer Maria Rilke (page 25), yet in a new color treatment it took on a completely different identity.

I was in heady company for this project; it was the first of many restaurant collaborations with the legendary architects Bogdanow Partners. Larry Bogdanow and Warren Ashworth were known for using natural materials and expert craftsmanship to create beautiful yet comfortable spaces. Collaborating with them allowed me to think beyond two dimensions. I had the pleasure of working with Bogdanow on many other projects, including Metro Grill, the Screening Room, Wild Blue, Savoy, Beekman Kitchen, and Grassroots.

The chef of Union Pacific, then-rising star Rocco DiSpirito, showed himself to be a true perfectionist both inside the kitchen and out. This was the first time that a chef asked to take home the computer file for the menu design to "look at other fonts." He also accompanied me on a press check for the business card. I enjoyed and benefitted from Rocco's attention to detail.

41

METRO GRILL

Garment-district oasis

When the bolts of fabric arrived at my studio and I unrolled them, I was surprised to see that the rows of stars were not exactly aligned. Since the position of the label in relationship to the stars was so critical, one of my designers had to mark each cut with tracing paper and straight pins before any scissors could be wielded.

IT IS UNUSUAL FOR RESTAURATEURS TO DEVOTE A GREAT DEAL OF time to naming an enterprise. Often they will come up with a mediocre name and pass it over to me, assuming that the logo will make up for its shortcomings. Metro Grill is a classic example of a default name at work. The clients' best shot was the very unsexy Pete's, which I vetoed. Finally, with the opening date looming, they decided to name it after the Hotel Metro, where it was located. It was not a very inspired choice, but considering the alternative, I was extremely grateful.

Next challenge: the concept. The hotel is situated on a somewhat dreary block in the West Thirties, in the middle of New York's garment district. I had my inspiration: make the logo a stitched clothing label. I found a sample of the upholstery fabric used for the banquettes, inserted it into a menu sleeve with a vintage dress label, and presented it, with the assurance that it wouldn't cost anything—well, hardly—since we would use remnants. This was very well received, until I found out that none existed. By then, fortunately, the client was already sold on the idea, and we ended up ordering three different fabrics, only one of which was being used in the restaurant. The woven labels were custom fabricated (minimum quantity: 5,000), so we needed to find other uses, and fast. We had them sewn onto the chefs' baseball caps and the servers' shirts, and the identity was complete.

THE MERMAID INN
New England in the East Village

Every year I like to give my senior portfolio class the assignment of reimagining this identity. I make a point of handing it out in the dead of winter, which is exactly when I had to do it—the absolute worst time to design something with a beachy theme.

DANNY ABRAMS AND JIMMY BRADLEY, OWNERS OF THE HARRISON, described their new project to me as "a seafood shack that you would stumble upon while walking along a New England beach—except that it is in the East Village." Although I always stand by an old mantra from my book-jacket days—"Never illustrate the title"—every rule has its exception. In fact, this logo broke several rules and yet managed to be memorable. Not only is "mermaid" expressed twice—in both type and image—but the word is hyphenated rather awkwardly inside illustrator Anthony Russo's winsome, slightly modest sea creature.

Beyond the matches and menus, I found a new challenge: the check presenter. To capture the quirkiness of the locale, we opted for an empty sardine can. And to assuage the clients' fears of sharp edges leading to lawsuits, I personally painted the edges of each can with clear nail polish.

This was an instant hit with the Mermaid clientele. Two weeks later, however, I got a call asking for twenty-four more. This time I hired my teenage son to do the job (and he hasn't been able to look at a sardine since). A few weeks later when I got a request for even more, I dropped in to investigate, whereupon I learned that there are two kinds of people in the world: those who go into an elevator and push their button once, and those who press it repeatedly. If you are in the latter category, it is *you* who wrecked my check presenter! (Apparently, some just couldn't help playing with the pull tab).

Mermaid Oyster Bar opened in 2010, necessitating a brand extension: the iconic ladyfish was flipped, and a pearl choker added around her neck.

1 Custom-printed paper for butter dish
2 The check presenter, before its sad demise
3 For dessert, each diner receives a fortune-telling fish with a signature espresso cup of chocolate pudding.
4 Hand-lettered business-card backs for each of the three restaurants
5 Dinner menu incorporating the custom scrawl from the logo

Raw Bar

...ers *chili or champagne mignonette* 10
...lams *horseradish~tomato relish* 6
...rimp cocktail *by the piece* 2.5
...1/2 dozen clams, 4 pieces of shrimp MP

Appetizers

...calls *lemon-roasted garlic aioli* 11
...pinach dip *old bay croutons* 12
...ar tar-tar *celery root chips* 10
...d codfish *old bay croutons* 12
...vder *smoked bacon and thyme* 6
...baked seafood imperial 9
...ens *tomato-caper remoulade* 9
...dijon, pilsner, scallions and garlic 8
...oasted beets, parmesan, crispy shallots 7

Entrees

pan seared diver scallops *braised cabbage, horseradish-bacon beurre blanc* 17
pan crisped skate sandwich *grilled red onions, citrus remoulade* 14
grilled salmon filet *asparagus-leek homefries, grainy mustard* 16
whole grilled dorade royale *wilted greens and sherry vinegar* MP
spaghetti with a salad on top *shrimp, bay scallops, and calamari* 15
grilled black sea bass *haricots verts, shitake, and blood orange* 18
catalonian seafood stew zarzuela *lobster, scallops, mussels, and clams* MP

Vegetables

sauteed greens *sherry vinegar* 5
buttered carrots *melted shallots* 5
mashed potato/lobster mash 4/8
old bay fries *malt vinegar* 5

The Mer-Maid Inn

ARTISANAL

Say cheese!

———✳———

The oversized bistro menu was so text-heavy that we had no place to put the logo; we ended up treating it as a watermark. The logo and red rule were preprinted so that the restaurant staff could typeset the daily menu in-house.

A RTISANAL, A FRENCH BISTRO SPECIALIZING IN CHEESE, WAS THE offspring of Picholine chef/owner Terrance Brennan. Like its sibling, this eatery suffered from the problem of an unpronounceable name. I decided to design the logo as a cheese label and gathered as much reference material as possible. While most cheese labels are round, with rather quiet graphics, I opted for an oval shape (since the word *artisanal* was too long to fit comfortably around a circle) and devised a French deco–inspired type treatment. Wood engraver Christopher Wormell was commissioned to create a pastoral scene for the central image and managed to meet the client's demands for a very particular type of barn and sheep—and even clouds. The business cards and menus were printed on duplexed Mohawk Via Sunflower vellum cover, and for other printed materials the shade of yellow was created as a special match. Just after the restaurant opened, Pantone introduced a series of new colors, and that exact yellow happened to be one of them. The logotype was adapted for business cards, matches, plates, chefs' jackets, tags, delivery trucks, awnings, and even the round butter papers. The tale of the interior design, by architect Adam Tihany, has an element of symmetry: the same space was the site of Tihany's first restaurant design in 1981, for La Coupole. His deco light fixtures (based on those in the legendary bistro La Coupole in Paris) had remained through several non-French incarnations and at long last appeared once more in their appropriate setting.

SFOGLIA

Two islands, two mermaids

———✳———

Shortly before the opening of this pasta-centric restaurant, a large blank wall in the dining room cried out for attention. I took an old pasta chart from a flea market in Rome and substituted PASTA SFOGLIA for the existing headline, then enlarged it to make a four-foot-tall print.

WHEN CHEF/OWNERS RON AND COLLEEN SUHANOSKY DECIDED to expand their very successful Nantucket restaurant to the Upper East Side of Manhattan, they contacted me to discuss a new logo. *Sfoglia* (pronounced SFOLE-yah), the Italian term for sheets of uncut fresh pasta, was going to be a challenge to communicate graphically. After a disastrous attempt at crafting the word out of fettuccine, I opted for a stylish 1920s script inspired by a gelateria sign I had once seen in Bologna. Feeling the need for another element, I turned to a book of heraldic symbols that often comes to my aid when I am in search of an idea. Out jumped a crest made of two mermaids. Of course—two islands, two mermaids! I had the image redrawn, putting sheaves of wheat in their arms and pasta shapes on the shield. Once I saw the final version, I realized I liked it too much to use it as a mere secondary element—this was the logo. I added banners under each mermaid labeled Manhattan and Nantucket, but Ron preferred NYC and ACK. (The latter is the airport code for Nantucket, which is used by those in the know to refer to their little island.) The revised type for the restaurant name was hand-lettered, based on Erasmus Titling from the early 1920s.

The sign on the windows of the restaurant is probably my favorite use of one of my logo designs. Jerry Pagane, a signage artist who has crafted most of the gold leaf seen in New York, created two six-foot versions of the logo backed with alternating blocks of translucent blue vinyl. It makes for an eye-catching greeting to taxi riders speeding down Lexington Avenue.

Sfoglia's signature dish weds type, color, and calamari: fried squid is served artfully wrapped in the headlines of the pale-pink Italian newspaper *La Gazzetta dello Sport*.

BEDFORD POST
Movie-star restaurateur

---❋---

I gained a whole new appreciation for postage stamps while working on this project. Not long after the design was complete, the opportunity arose to design an actual stamp for the U.S. Postal Service.

THIS LOVINGLY RESTORED CAFE, RESTAURANT, AND INN IS SITuated forty picturesque miles north of New York City, on the historic Old Post Road (once the mail-delivery route between New York and Boston). At an initial meeting with the owners, actor Richard Gere and his wife, actress Carey Lowell, I proposed the idea of fashioning the logo into a postage stamp. They were intrigued by the concept, so we began to discuss imagery. Gere responded immediately. "I have a wonderful photograph of my grandfather standing in a wheat field," he said, and jumped to his feet to act it out. Everyone in the room was completely transfixed. I was promised the photo for the next day; it did indeed arrive and was exactly what I expected—a small, gray, blurry snapshot. I wasn't deterred, however, for this is why we have illustrators! I contacted Canadian scratchboard artist Mark Summers and bought a book on the history of postage stamps to study traditional layouts, proportions, typography, color palettes, and decorative elements.

After putting together three different design options showing type, banner, and borders (using the photograph as a placeholder), we selected one direction and sent it to Summers to render in scratchboard. Once he completed his part, we incorporated hand-lettered type and explored color options. I showed the finished logo in four traditional stamp colors; since all were preferred equally, we decided to print the business cards using the complete color palette, in the hopes of creating a collector's item.

52

BEDFORD POST

{ www.BedfordPostInn.com }

Address
954
OLD POST RD.

Telephone
{ **914** }
234.7800

BEDFORD
NEW YORK

1 0 5 0 6

1. *Sample postage stamps used as inspiration for the logo*
2. *Original reference snapshot of the client's grandfather standing in a wheat field, circa 1950*
3. *A preliminary sketch of the logo using the postage-stamp concept*
4. *Sketch using photo as placeholder*
5. *A series of color comps in square and horizontal formats*

6 *Initial sketch by Mark Summers in sepia tones*
7 *Summers's sketch placed into design*
8 *Sign for the restroom door*
9 *A limited edition of twenty-four check presenters was handmade by a bookbinder, featuring deep plum cloth and a die-cut sticker placed in a debossed panel. The waitstaff were given strict instructions to not let these out of their sight.*

BOLIVAR

Argentina on East Sixtieth Street

—✷—

I had originally selected an uncoated stock for these menus. When I went on press, all the colors matched perfectly except for the green, which appeared mottled. The pressman's answer? "Don't use green." Instead, I begrudgingly changed to a coated stock.

WHEN THE OWNERS OF THE WILDLY POPULAR UPPER EAST SIDE eatery Arizona 206 decided to switch from southwestern to Argentine cuisine, I was in the throes of designing *Deco España* (page 187), and I had become particularly enamored of a style of 1920s typography that used chunky two-tone letterforms, often with a big dot over the lowercase *i*. This inspired the logo for Bolivar, which was graphic enough to hold its own as a menu cover. The clients insisted on a specific color palette that reflected the paintings that would hang in the main dining room. To my great surprise, on my first visit to the finished restaurant, the paintings were nowhere to be seen.

In spite of the absence of artwork, the restaurant garnered excellent reviews. Less than a year after the opening, however, the owners succumbed to pressure from devotees of the previous incarnation and turned it back into Arizona 206 (until it closed for good a year later).

MÉTRAZUR

The French Riviera meets Grand Central

———※———

The menu paper stock, Champion Benefit Ocean cover, was chosen to approximate the blue background of the iconic ceiling zodiac at Grand Central Terminal.

Located in the airy and elegant mezzanine space at Grand Central Terminal under the famous *Sky Ceiling* mural, Métrazur was named for a French train line along the Côte d'Azur. (The original client, Matthew Kenney, had a penchant for giving all of his restaurants names that started with the letter *M*.) Although I had applauded Grand Central's vigilant design police for removing the oversized Kodak billboard that had visually assaulted the space for so many years, their strict design sanctions made it virtually impossible to create a sign for the restaurant. The restrictions were so confounding that I had to start with the signage and work backward to the logo design. Basically, these were the guidelines: nothing could be attached to anything that was part of Grand Central. No sign, no hardware, no lettering—nothing. In other words, the marble wall at the top of the dramatic staircase could not display a logo. (When I suggested a hologram, no one was amused.) My original concept was to make a script out of a dotted line, to echo the patterns of the ceiling constellations. The signage would be made out of tiny lights (which wouldn't touch the wall), and the type on the business card would be created from perforated dots. When that idea was nixed by Grand Central, it was time for Plan B: a deco-inspired font would be letterpressed on both sides of a luggage tag, with a grommet and string attached. A strip of pressure-sensitive tickets was printed for use on the menus and other components.

SALADS

MÉTRAZUR SALAD
in the caesar-style,
parmesan tuilles 9.

**HARICOTS VERTS, GOLDEN
BEETS, CRANBERRY BEANS,
FRISÉE AND ARUGULA**
toasted hazelnut dressing 8.50

**MESCLUN, ENDIVE, AND
OVEN-DRIED PLUM TOMATO**
balsamic vinaigrette 7.50

PASTAS

**SPICY BRAISED VEAL RAGOUT,
SPINACH AND LEEKS**
over rigatoni 17.50

**POTATO GNOCCHI
WITH PORCINI MUSHROOMS**
asparagus and sage cream 18.50

**ROSEMARY AND THYME
MARINATED PORTOBELLO
MUSHROOMS**
grilled, over penne 18.

WOOD-OVEN FLAT BREADS

PROSCIUTTO, FIG,
ARUGULA AND LEMON OIL 11.

ROAST PEPPER,
GREEN OLIVE AND THYME
SCENTED GOAT CHEESE 14.

CARAMELIZED ONIONS,
AND ROSEMARY 11.

ANOTHER CHARLIE PALMER
RESTAURANT

CHEF DAVID RUGGERIO
CHEF MICHAEL LOCKARD

WOOD-OVEN FLAT BREADS

PROSCIUTTO, FIG, ARUGULA
AND LEMON OIL 10.

ROASTED PEPPERS, GREEN OLIVES
AND THYME SCENTED GOAT CHEESE 9.

PORCINI, CARAMELIZED ONIONS,
AND ROSEMARY 10.

RAW BAR OFFERINGS

SELECTION OF OYSTERS
belon
wellfleet
kumamoto
(1.75 EA. MINIMUM OF 6)

LITTLENECK CLAMS
mignonette cocktail sauce and lemon 9.

SHELLFISH SELECTION
(minimum 2 persons) 26.

LOBSTER AND SHRIMP PARFAIT
citrus-clabber cream, mango and candied ginger 12.50

"FLIGHT" OF OYSTER SHOOTERS
champagne ice and brunoise cucumber 9.

PRAWN KEBAB
piquillo pepper purée 19.

MAIN COURSES ACCOMPANIED BY MARKET VEGETABLES

92

An American bistro

This logo served as good practice for the SVA subway poster that I would design a decade later (page 234). Little did I know how much more challenging it would be to create thirteen words out of mosaics, rather than a mere two-digit number.

How can a two-digit number possibly make an interesting logo? 92 was yet another restaurant with a default name "inspired" by the street on which it happened to be located. Moreover, the client didn't yet have a handle on his restaurant's concept. In talking this through, I convinced him that it should look as if it had always been there—an American classic.

While waiting on the subway platform en route to the construction site, I found myself studying the mosaic tiles, always a source of fascination. Fabricated in the early 1900s, no two numbers are alike. I returned with my camera and photographed every nine and every two on both the east- and west-side lines. The images were pieced together digitally to create the logo (as there is no such station in the subway system). The longer I worked on it, the more I became convinced that a Ninety-second Street stop really did exist.

When I examined the final digital file and discovered an outline layer, I realized that we had our children's menu. Young diners would be given a placemat with red, yellow, and green crayons. The client was pleased. As he said, "This will keep them busy for a long, long time."

60

61

TXIKITO
Basque cuisine in Chelsea

---※---

Sometimes when I sketch a logo, I get so carried away that I accidentally change the spelling. Since this word was quite unfamiliar to me, I started out with the correct spelling but it soon morphed into Txitiko! Fortunately I noticed this shortly before the presentation, and necessary changes were made. Note to self: a client isn't likely to love a logo that is misspelled.

Husband and wife Eder Montero and Alex Raij teamed up to open a restaurant in Chelsea, focusing on Eder's native Basque cuisine. Its name, Txikito, means "little one" in Basque dialect. At our initial meeting, I was charmed by their enthusiasm. We agreed that with such an unusual name, we should keep the logo purely typographic. We spent an afternoon paging through one of my favorite reference books, *Barcelona Grafica,* an exhaustive documentation of the shop and restaurant signage of Barcelona, and we each flagged our preferences. Every time anything appeared that resembled brass (which was used throughout the restaurant), Eder's eyes shone like the metal itself. We identified several interesting approaches, from hand-painted letters to a twisted metal script. Although we created three different logo options, I kept hearing Eder's voice saying *braaahsss,* so I knew which one to focus on. The script was drawn in pencil, then scanned in, and color added in Photoshop. Certain that I couldn't be the only one incapable of uttering Txikito properly, I insisted on a phonetic spelling on the back of the business card, for other tongue-tied non-Basque speakers. A gold-leaf sign on the front door completed the restaurant's distinctive identity.

BEER AND CIDER

Draft Beer: Zurito 3oz. • 3 Caña 12oz. • 6
Farnum Hill Cider: Basque-style cider made in New Hampshire • 9

COCKTAILS

Zurracapote, "Zurra" fortified wine cocktail • 8 glass / 29 pitcher
"Gintonic" Plymouth Gin, bottled tonic • 11
"Ginkass" Plymouth Gin, Spanish lemon drink • 10
Cuba Libre Premium rum, bottled coke • 10
Soft drinks • 2-3

Ardoa
WINES

Champagne: "Agua de Bilbao"
NV Paul Laurent Brut, Epernay • 12 glass • 130
NV Alfred Gratien Brut Classique, Epernay

[business card: 240 ninth avenue, between 24th & 25th, New York NY 10001, Txikitonyc.com • 212.242.4730 — CHIC KEE TOE]

[Txikito cocina vasca — matchbox: 240 NINTH AVE (24th & 25th) • NYC, TXIKITONYC.COM • 212.242.4730]

Ostatutik
FROM THE BAR

GILDA: olive, Basque anchovy, guindilla pepper • 2
OLIBAK: Spanish olives • 4
PATATAK: Potato chips • 3
PINTXOAK: Basque Canapés
ESKONTZA: 2 kinds of anchovy, fresh tomato and sweet pepper on br... • 12
FOIE MICUIT: homemade Foie gras terrine • 7
ARRAIN PASTELA: homemade fish pate • 8
TXIKI TXANPI: mini mushroom and shrimp grilled cheese • 7
MARIJULI: sweet pepper, tomato, jamón serrano • 9
SOLOMO ADOBATUA PIPERREKIN: house cured pork loin, roasted green pepper • 8
ARRAULTZA: sofrito, palacios chorizo, 6 minute egg • 8
ATUN OGITARTEKOA: little sandwich of Basque tuna, piquillo oil, sweet onion • 8
TUTERA: artichoke, roncal, jamón de serrano • 9
TXITXIKI OGITARTEKOA: crispy sandwich of housemade chorizo hash • 9

Otsak
COLD ITEMS

...lad; potato, imported tuna, piquillo, homemade mayo • 14
...with Navarran asparagus, imported tuna, egg • 12
...ive oil, sea salt, parsely • 15
...joram, Pimente d'espilet
...cooked egg • 13

PACE

Pah-chay, as in peace

In addition to my load of books, I filled another suitcase with a kilo of carta paglia *(a rough, ochre-colored paper once used to wrap cheese in Italy) to use for the menus.*

PACE WAS ANOTHER VENTURE BY JIMMY BRADLEY AND DANNY ABRAMS, proprietors of the Mermaid Inn and the Harrison. An Italian restaurant in Tribeca, it was situated in a cavernous space with stuccoed walls painted in rich earth tones. In an attempt to replicate the textures and colors used in the restaurant, I adapted the logo from a 1920s French alphabet. The severely angular letterforms could be used only in small doses: four letters seemed to be just about right. However, there was very little I could do to teach the general public to pronounce this name correctly. Everyone read it as PAYCE, not PAH-chay. In a last-ditch effort, I designed a tiny sticker to seal the matchboxes (as required by law in Italy), with the word *peace* in parentheses to help guide people along.

After deciding to use Italian novels as check presenters, I left for Venice, where I struck gold: a remainder bookstore was selling a handsomely designed line of Italian fiction (of just the right size) for only one euro per book. I filled my suitcase (adding an extra set for myself). Back in New York, the check was slipped inside the book, where the credit card could join it on the return trip. The books were well received (and mentioned in the *New York Times*) but also well pocketed by guests, who took them for giveaways. I was more than willing to return to Italy with an empty suitcase, but before long another restaurant with an unpronounceable name was history.

THE SCREENING ROOM
Dinner and a movie

This restaurant was a favorite place to hold studio parties; in a cushy private screening room, a group of twenty could watch a movie on a wide screen while enjoying dinner.

In 1993 I designed a jacket for a Grove Weidenfeld book called *The Thing Happens*—arguably one of the worst titles in the history of publishing. It was actually a very fine collection of essays by Terrence Rafferty, then the film critic at the *New Yorker*—but who would have known that from the title?

In an attempt to compensate for this misnomer, I had hired photographer William Duke to create a black-and-white photomontage from plaster display letters once used for home-movie titles, combined with images of various cinematic elements. Years later, when I was asked to design the graphics for the Screening Room, a Tribeca restaurant and cinema with a 1940s theme designed by architect Larry Bogdanow, the plaster letters came to mind again. By then, unfortunately, Mitten's Movie Titlers had gone out of business. Instead, I was obliged to order them in plastic from a signage company and then spray-paint and sand them to keep them from looking too perfect. Duke had since moved to California, so we had to work long-distance this time. Different movie-themed props were used for the business card, matches, letterhead, envelope, and menus, which were printed in rich duotones. Each component projects the aura of old Hollywood, especially my favorite, the dessert menu (*Fin*).

67

① *Instructional photograph from a 1920s etiquette book, employing composed letters and dramatic lighting* ② *The photograph inspired the jacket design for this collection of film essays.* ③ *The plaster letters for the book jacket had been ordered individually from Mitten's Movie Titlers, which was out of business by the time I needed them for the Screening Room. Instead, plastic letters were used.* ④ ⑤ *After completion of the Screening Room design, I stumbled across this set of letters in an antiques store.*

ROSEVILLE
San Diego Victoriana

---※---

When this restaurant breathed its last, I attempted to negotiate for the neon sign, which I thought would look quite lovely in my studio. Unfortunately, the shipping costs would have been prohibitive.

ALTHOUGH I HAD NEVER BEEN THERE, HOW COULD I NOT LOVE A locale named after a flower? The historic Roseville neighborhood of San Diego (actually named after developer Louis Rose), has its roots in the late nineteenth century, when it was an independent city. For the restaurant of the same name, I imagined an elegant Victorian type treatment. I also considered the lush floral designs of Roseville pottery (although I later discovered that I had been misinformed by the client, and it was actually made in Roseville, Ohio). A graceful and intricate upright Victorian script that I had always wanted to use had finally found its home. The alphabet was adapted for the logotype and then simplified and made into a font, along with a family of ornaments, for use on the oversized, single-panel menu.

I liked the idea of designing the logo in an antique type style but in all lowercase, which made it feel more modern. As a counterpoint, a very ornate capital initial *R* was printed on the coasters. The final component was a neon version of the logo (in a salmon color, but without the flourishes), which illuminated the restaurant's facade.

roseville

starters

HAZELNUT DUSTED VEAL SWEET BREADS
Yukon gold potato puree, endive salad & pancetta vinaigrette – $15

DAILY SELECTION of OYSTERS
on the HALF SHELL
½ dozen – $15/dozen – $15

STEAMED CARLSBAD MUSSELS
baby fennel, charred ramps, & orange salsa verde – $15

ASPARAGUS SALAD
truffle vinaigrette, curly endive, farm fresh egg & crispy capers – $15

SPRING VEGETABLE SALAD
baby artichoke, fava beans, corn, French feta & creamy mustard – $15

SOUP du JOUR – $15

CRUDO du JOUR – $15

DUCK CONFIT RILLETES
medjool date, violet mustard & sauternes onion confit – $15

FRESH RICOTTA GNUDI
morel beurre fondue, English peas & summer truffle – $15

ROSEVILLE 'BOUDIN BLANC'
Smoked tomato confit, Rouille, roasted Tinkerbell peppers & fines herbes (seafood sausage composed of mostly lobster & shrimp) – $15

entrees

SALT ROASTED SANTA BARBARA SPOT PRAWNS
Tomato Risotto, basil pistou & petite arugula – $15

HUDSON VALLEY DUCK CONFIT
Braised Rainbow Chard & Duck Jus – $15

OVEN ROASTED WHOLE POUSSIN – $15
roasted marble potato, cioppolini onion & French green beans

GRILLED LOCAL HALIBUT
Halibut 'brandade', whole grain mustard crème fraiche & bread crumb salsa – $15

SEARED DIVER SCALLOPS
olive oil crushed purple potato, parsley, lobster & Pernod- Sea urchin emulsion – $15

VEAL CHEEK 'BOURGUIGNON'
pearl onion, chanterelle mushroom & pappardelle – $15

OVEN ROASTED MEYER FARMS DRY AGED RIB EYE
Pommes Frites & Au Jus – $15

weekly

MONDAY	TUESDAY	WEDNESDAY	THURSDAY	FRIDAY	SATUR...
Provencal Stew of Fresh Fish and...	Oven Roasted Whole Fish ~$15~		Local Swordfish Nicoise ~$15~	Veal Osso Bucco Milanese ~$15~	Filet A...

a la carte

POMMES FRITES
BRAISE CRANB...
ORECCETI...
RAINBOW...
...POTATO PUREE – $15
...TTERS – $15

george rif...
{ in the Village of...
1125 Rosecrans Street, Sa...
Tel. 619.223.7300
Email: george ROSEVILL...

CANDLE CAFE

Vegan elegance

———✳———

Part of my job as a menu designer is to correct spelling errors, and there are often many. For Candle Cafe, I changed items like "oat cheese" to goat cheese, until I discovered that this was in fact a vegan product, not a typo.

WHEN I DESIGNED THE IDENTITY FOR THE UPPER EAST SIDE organic, vegan eatery Candle Cafe in 1994, I was adamant about not depicting a candle. Why say it twice? Instead, we created an iconic glowing leaf-cum-flame. The restaurant's stationery system made the most of the fine-detailed engravings in my archive of antique seed catalogues, which serves as the inspiration for many projects. (I made enlargements of a cabbage and a cucumber for the doors of the ladies' and men's rooms, respectively, but one of the managers was offended and refused to use them.) After the success of the original cafe, and in order to accomodate their ever-growing loyal clientele, the owners opened the more upscale Candle 79 in 2003, for which I designed a companion logo using the same image. In both instances, wood typefaces were combined with the engravings to represent the restaurant's unique blend of sophistication and rusticity. The menu covers were fabricated in a rich palette of deep plum, burgundy, mushroom, and deep violet, with linen liners of earthy ochre and violet. As always, a trip to M&J Trimming in the garment district yielded the just-right match of color for the satin ribbon corners of the menus.

Although the Candle staff was obdurate regarding the use of recycled paper and soy-based inks for the business cards, they appeared strangely cavalier about their carryout packaging, which happens to be plastic. (Apparently, it is a storage issue.) This has spawned an ongoing debate; as a result, I always make a point of bringing my own containers to the restaurant.

1307 THIRD AVENUE NEW YORK CITY NEW YORK 10021

CIVETTA

The flirtatious owl

———✲———

One direction I tried for the logo was to make the v of Civetta into the beak of an owl, with the top of the letter curving left and right to suggest eyes. It seemed a little too ominous for a restaurant.

Sfoglia chef/owner Ron Suhanosky's Nolita eatery, Civetta (which means "owl" as well as "flirt" in Italian), was targeted to a hip downtown clientele. The mandate was quite emphatic: no owls in the logo (a solution that never would have crossed my naturally counterintuitive mind in the first place).

I took my type cue from bold, fanciful Italian art-deco letterforms, adding a bit of whimsy with curly drop lines. This black and metallic-gold treatment was used for the logo as well as the extensive signage, which was screened onto long, bistro-style mirrored panels and mounted on the considerable facade of the restaurant. Once the logo was in place, Ron backtracked: could he have an owl as well? Somehow, the only way I could accept this mascot was to make it wink. I delivered the image only on the condition that the logo and owl would never be seen together. Civetta kept its word.

Custom water bottles with glass stoppers were designed for both sparkling and still water. (The label is shown at right.) The menu features a sticker with the winking owl printed in black and metallic gold, set into a debossed panel on a gold cloth background.

My first (and only) dinner at Civetta was delicious, and the interior and graphics looked spectacular. Unfortunately, the intense rumbling of the number 6 subway line directly below the restaurant was intolerable. Before I'd had a chance to engage a photographer to document the facade, this bird had flown.

GASSATA

PACKAGING

In 1992, when I was in Milan researching a book on Italian Art Deco, I found myself one stifling afternoon in a *magazzino*—a warehouse—filled with printers' proofs of labels and other ephemera from the 1920s. What instantly caught my eye was a series of *pasticceria* papers—fancifully patterned waxed papers once used to wrap pastries. All created by hand, they were the most inspiring graphic works I'd seen in a long time. A thunderbolt had struck, and I decided to shift my focus to food packaging. Once again I was on a mission to prove that a design needn't shout to be noticed. Why couldn't food packaging be as seductive—and collectible—as book jackets? I began to experiment with the tactile elements that I had used in my restaurant work, such as luxurious paper choices and special printing effects, and applied them to boxes, bottles, and jars. With that, I became a package designer.

Heirloom

BELLA CUCINA
Mediterranean-inspired, Atlanta-produced

---※---

Details such as tiny brass grommets to close the biscotti bags and hand-tied twine to secure the handkerchiefs on the jars are part of what make the line of Bella Cucina products unique.

BELLA CUCINA'S SIGNATURE PRODUCT IS SO BEAUTIFUL THAT IT scarcely needs any graphic embellishment. The company's preserved lemons, artfully accented with olives and bay leaves, are quite striking on their own. For more than a decade, I have been working with Bella Cucina on packaging a dizzying array of Mediterranean-inspired products—citrus-scented extra-virgin olive oil, biscotti, pestos, pastas, dessert sauces, crostata, *pane rustico*, aromatic savory salts, and dipping crackers, each in its own distinctive bottle, jar, or box. The graphics, which are rooted in the nineteenth century and earlier, feature hand-colored engravings and delicate typography to complement the products' artisanal origins. The typefaces are a melange of a 1920s French hand-tooled font and an italic version of Bodoni, which I saw for the first time at the Museo Bodoniano in Parma, where an earnest attendant with dustcloth in hand chased me around the locked display cases. I had always wanted to use this font, and Bella Cucina provided the perfect occasion. Over the years I have amassed an archive of fruit and vegetable engravings, which are constantly being dissected and rearranged to fit inside circles and other challenging shapes. Occasionally I am stumped and will resort to commissioning an illustration. All of the labels, handkerchiefs, hangtags, and strings are painstakingly applied by hand. And even though the products seem too beautiful to eat, they taste as good as they look.

81

JEAN-GEORGES

California with a dash of Provence

———✻———

This was my first experience with a label printed on metal, which was somewhat terrifying, although the final product looked exactly like our glossy Epson prints. While the idea of an unprintable side strip that would interrupt the background pattern had initially been a great source of anguish, I admit that I no longer notice it.

In the early 1990s, grapeseed oil was introduced to the culinary world and was an instant favorite of chefs and food enthusiasts, who were taken with its high smoke point, clean taste, and health benefits. When celebrated New York chef Jean-Georges Vongerichten decided to market his own grapeseed oil, the packaging needed to reflect both his own aesthetic and that of distributor Williams-Sonoma. I proposed a design that combined Californian and French sensibilities—a West Coast color palette applied to a traditional Provençal background motif. The display type, based on a wood-type alphabet, was created expressly for this project. Partway through the design process, the product was divided into two separate but similar brands—one to be sold exclusively at Williams-Sonoma (which would bear the California Grape Seed name) and another to be sold elsewhere under Jean-Georges's name. The dual identities necessitated the design of two custom monograms (below and right).

82

SARABETH'S
Reinventing a legend

The new graphics treatment was carried over to Sarabeth's bakery, restaurant, and kitchen, as well as her gift boxes, hot chocolate, cookies, and an award-winning baking book.

AFTER NEARLY A QUARTER-CENTURY, THE ACCLAIMED SARABETH'S WAS long overdue for a makeover. Although the signature jar of Orange Apricot Marmalade was immediately recognizable, it was time to trade in do-it-yourself for designed. The existing label (page 170) had suffered in the hands of a printer for far too long; it reeked of Microsoft Word. Why else would the tag line, *Spread the Word*, be italicized, underscored, *and* set in quotes?

As much as she comprehended that a change was necessary, Sarabeth Levine feared alienating her loyal customer base and was understandably apprehensive about the financial investment—not only for the design but also for reprinting front and back labels for a hefty inventory of fourteen products in four different sizes. I assured her that we could update the overall look while retaining a few key elements of the original packaging. And rather than losing her customers, she would gain a new market.

Keeping the iconic Mason jar, I recommended changing the generic printed gold lid to plain silver. While it was important to maintain the oval shape of the label, the typography could be refined, employing a more classical and sophisticated type style. In addition, we added a simple, elegant border and replaced the previous artwork with more precise engravings of fruit. The design was adapted for an array of other products.

The fresh look was subtly yet strikingly different, which served to underscore the classic identity. And Sarabeth could stop worrying. In her own words, "Not only is our product great, but now it *looks* really great."

LATE JULY
Vintage crackers

Nicole Dawes named her three-generation company after what she calls the "sweet spot of summer"— that perfect moment that evokes carefree childhood memories. The design of the Late July box sought to translate that feeling into type.

OFTEN THE MOST APPROPRIATE VISUAL REFERENCE IS RIGHT THERE in plain sight. When a new client came to speak to me about designing a line of organic crackers, I proposed the idea of a vintage-inspired package, which was well received. I started gathering early twentieth-century package-design reference materials, and only after making several sketches did I happen to glance at my windowsill, where a beautiful old cracker crate had been sitting for years as a repository for jar and bottle samples. It was the perfect inspiration for this product. After creating many sketches based on the crate's letterforms as well as a family of metal type from the same period, we custom-lettered the final, approved composition. The entire package was hand-lettered—even the net weight—in order to achieve a seamless period design. I hired Graham Evernden, a British illustrator who works in a pointilistic style that approximates early chromolithographic techniques, to execute the images of the wheat, crackers, boy, and dog (in the likeness of the client's pet Briard). The most challenging task for the illustrator was to accurately portray the Cape Cod scene—literally foreign territory to him.

Although the unappetizing color blue is rarely used in food design (or by my studio), the rule has its exceptions: saltine crackers are traditionally, yet curiously, represented by navy blue.

LATE JULY

ORGANIC

CLASSIC RICH CRACKERS

Net Wt 6oz • 170g

1 *Initial sketches for the front of the box refer to package design from the early twentieth century.* **2** *Lettering samples from type-specimen books as well as a vintage cracker crate in my studio.* **3** *Preliminary sketch by illustrator Graham Evernden.*

4 *Final image, approximating a chromolithographic style* **5** *Lettering integrated into a preliminary black-and-white version of the illustration* **6** *An early attempt at color, using final illustration* **7** *Additional graphic elements by Evernden*

TATE'S
Everyone's favorite cookie
---※---

Although net-weight regulations are the scourge of designers, I was very pleased with how that information was integrated into the design of this package.

MOST CHOCOLATE-CHIP-COOKIE AFFICIONADOS WILL AGREE THAT Tate's rates among the best, hands down. In her quaint, otherworldly bake shop in Southampton, Long Island, Kathleen King creates classic confections that evoke storybook images of white picket fences and pies cooling on windowsills. When Kathleen first approached me to redesign her packaging, I immediately thought of the classic American image of cookies and milk; why not design the package to resemble a carton of milk? I worked with a manufacturer to develop a prototype; the boxes were printed in metallic inks and color-coded to indicate chocolate chip (green), oatmeal raisin (purple), and macadamia nut (red). Stickers were designed and applied to cellophane bags to introduce a much broader range of products for impulse sales, including cakes, pies, brownies, and blondies, and, more recently, gluten-free selections. To complement the crisp colors, we selected elegant and clean type based on classic early twentieth-century illuminated letters. Two other interpretations of a decorated initial *T* were presented, but the final choice offered the correct dose of modern Americana. The subtle floral motif in the logo referred to the latticed vines on the side of Tate's mint-colored colonial-era building. The shade of green used for chocolate-chip cookies became the line's signature color used for business cards, gift boxes, and bags.

EL PASO CHILE COMPANY
Smokin' design

I was glad I was able to design this bold packaging for the El Paso Chile Company. Whenever I was told that the work of my studio was too feminine, I would point to these packages.

THERE WAS NO SUCH THING AS A NORMAL PROJECT WHEN IT CAME to the El Paso Chile Company, known for their lively graphics and witty copy lines. Their Scorch the Porch/Daddy-Q BBQ collection, complete with cast-iron frying pan and paint-can packaging (with a handy opener affixed to the lid), offered a perfect opportunity to use a family of bold wood types with overprinted colors, in the tradition of Hatch Show Print, one of the oldest letterpress shops in America. The Chili Spices & Fixins kit was packaged in a kitchen matchbox, to represent the heat it delivered.

The designs for the margarita mix and salt (next page), sold exclusively at Williams-Sonoma, were inspired by the work of nineteenth-century Mexican artist J. G. Posada. Looking for a rustic font pairing, I chose the principal type Pabst Old Style (designed in the early twentieth century by Frederic Goudy), which was pieced together from a specimen sheet. The complementary font was drawn to approximate a metal typeface commonly used in the 1920s Italian magazine *Le Grandi Firme*. With commissioned illustrations by wood-engraver James Grashow, this project provided an unforgettable lesson in the power of package design. The two products were the top sellers in Williams-Sonoma stores for nine years straight—even though I am told that the can, which was priced at seven dollars, contained twelve cents worth of salt. ¡Viva el diseño!

93

IRVING FARM

New York farm-roasted coffee

---※---

By featuring a portrait of the two owners sitting under a tree while enjoying a cup of coffee, Irving Farm gained a more personal connection to its customer base.

WHEN IRVING FARM'S OWNERS FIRST APPROACHED ME TO REdesign their coffee packaging, I was surprised that I had never heard of their company, especially when I learned that their cafe was only steps away from my studio, and their farm, where the coffee is roasted, was within minutes of my country house. Perhaps it had something to do with their unexceptional packaging. A generic silver coffee bag with a logo (page 176) designed by a boat painter (yes, a boat painter) made it clear that an intervention was in order. We agreed to print one coffee bag with separate flavor stickers. The bag design, which reinterpreted some elements from an original sticker that was a sentimental favorite, employed engravings and a hand-tooled font. The bag was printed in white and brown; elements that appeared to be printed in silver were actually reversed out of the bag's silver background. New stickers using a family of wood-type faces, color coded by category, allowed more room for descriptive copy. The new identity and packaging were a commercial success, but five years later, when the coffee was divided into three categories, a new bag design was required. A dose of color invigorated sales considerably.

AMERICAN SPOON

A passion for fruit

———✳———

When the client was initially resistant to the proposed label design, I suggested that we replace the dated English botanical illustrations that were being used as place-holders. We agreed to engage Charlotte Knox to create one sample illustration, which won the client over.

AMERICAN SPOON HAD BEEN MAKING ARTISANAL JAMS AND PRESERVES for over twenty-five years and was in desperate need of a new identity. Located in picture-perfect Petoskey, Michigan, this family business was all about the fruit. I was impressed by the personal relationships the owners maintain with their growers—if the black-raspberry crop wasn't good in a given year, they simply wouldn't produce that jam.

The existing logo (page 173) was somewhat generic; I wanted the new identity to communicate the importance of human interaction, so I commissioned wood-engraver Christopher Wormell to illustrate a figure shaking apples out of a tree, into a basket. Both the type and illustrations on the labels needed to have a clean, beautiful, and timeless look to match the quality of the product (which recalled the homemade jams of my childhood). Charlotte Knox's crisp, anatomically-correct-but-not-too-fussy botanical illustrations completed the design. (Ironically, it took two British illustrators to create an appropriate look for this very American company.) The font, which was adapted for the logo, was Odette, the digitized version of Announcement Roman, a typeface designed by Morris Fuller Benton in 1918, which I had used in hot metal years before. The revised lids, changed from clunky black and gold to an elegant printed silver, featured the logo on top and the American Spoon tag line, *Preserving the perfect flavors of fruit since 1982*, printed along the edge.

The design has been gradually phased in at the rate of one product line per year, and the new, improved look has steadily been making its mark.

103

L'ARTE DEL GELATO

La dolce vita

———✽———

It is always fun to see vehicles around town sporting logos that I have designed, but I must admit that my favorite is the über-cute Fiat Cinquecento for L'Arte del Gelato.

FRANCESCO REALMUTO AND SALVATORE POTESTIO CAME TO NEW YORK from Sicily to work as diamond cutters, but their longing for authentic gelato led them to a radical change of profession. Made only with the finest seasonal ingredients, their artisanal gelato is, as the tag line claims, *fresco ogni giorno* (made fresh every day), and it is as good as any in Italy. The company's logo, however, was utterly lackluster (page 175). My client Sarabeth Levine, a neighbor at Chelsea Market, simply commanded Francesco to contact me. (One doesn't dare argue with Sarabeth.) Before long L'Arte del Gelato had the logo it was always meant to have, as fine as its *frutto della passione* sorbetto or *stracciatella* gelato. Inspired once again by *pasticceria* papers and an ice-cream color palette, I drew upon a number of upright Italian script samples from the 1920s. For me, nothing is more blissful or timeless than gelato, and my goal was to capture that carefree mood in the graphics, which are used on business cards, cups, bags, take-out containers, signage, uniforms, a website, and even a small army of captivating carts found on the High Line and at Lincoln Center. The newest and most appropriate addition is a logo-adorned Fiat Cinquecento.

On any given day, there is a fresh supply of gelato and sorbetto available at my studio, which not only serves as good advertising but also guarantees that clients, staff, and students (and sometimes even my super) are kept happy at all times.

① *Original logo sketches, drawn in an old Italian ledger* ② *The awning fabric color was an exact match to the pink used in the logo.* ③ *1930s Italian pastry papers served as useful reference for the logotype.* ④ *Francesco had a cousin (of course) who expertly embroidered the uniforms.* ⑤ *The ubiquitous cart brings joy to all corners of New York.*

BIG ISLAND BEES
Organic honey from Hawaii

---※---

I never dreamed that there was so much to learn about organic honey—and Hawaiian flowers—until I worked on this project.

GARNETT PUETT IS A FOURTH-GENERATION BEEKEEPER. TOGETHER with his wife, Whendi, he produces organic and natural honey from bees fed on rare blossoms, some of which are found only in the couple's native Hawaii. Since authentic Hawaiian design reference material was virtually nonexistent—apart from flowered shirts—the identity and packaging for this unique honey required me to invent a graphic genre, which I like to call *tropical botanical.* For the initial presentation I produced comps using a placeholder hibiscus-flower illustration, which was as close as I could come to the very specific blossoms required, and I approximated the lettering in pencil. Once the direction was approved, I hired illustrator Dugald Stermer, whose nuanced imagery of flora and fauna and botanical-inspired lettering had just the right feel. Ohia lehua, macadamia nut, and wilelaiki blossoms were all new to both of us; after much photographic research and discussion, the clients supplied adequate reference materials, but since we couldn't travel to Hawaii to view the real specimens we relied on a certain amount of creative interpretation. The final artwork was used for both the logo and the individual labels. Stermer's drawings were masterful, as was his lettering, although the clients preferred my handwriting from the comps for the flavor names. As a result, the finished label was a hybrid of both handwriting styles, which managed to work despite—or because of—its unconventionality.

Q.BEL

All-natural chocolates

I am a firm believer in sampling a product while working on its design. It is the only way to truly understand the graphic needs of the project. For better or worse, Q.bel proved instantly addictive for everyone at the studio.

WHEN BAHRAM SHIRAZI APPROACHED ME ABOUT A NEW LINE of natural chocolates, I had three words of advice for him: *Don't do it*. I had grown weary of watching earnest, inexperienced food entrepreneurs crash and burn. He persisted, so I finally agreed to work with him, but only on the condition that he hire a consultant whom I recommended. Fortunately, he listened. Less than a year later, Q.bel all-natural chocolate wafer rolls and bars were launched to a warm reception.

The object poster, a type of advertisement introduced by early twentieth-century German designer and typographer Lucian Bernhard, was the inspiration for the package designs. Bold, rounded type and bright but sophisticated colors were used in an effort to reach a niche market. The logo suggests ever so subtly a smiling face. Ben Garvie's seductive, hyperrealistic illustrations completed the package.

IL MULINO
Packaging a classic

———✦———

When Presidents Obama and Clinton had lunch together in New York City one fine fall day in 2010, I was pleased to note that not only had they chosen to dine at Il Mulino, but that the New York Times *had opted to feature a front-page photo of them standing directly beneath the awning, emblazoned with our logo.*

IL MULINO IS ONE OF NEW YORK'S TOP ITALIAN RESTAURANTS— unassuming from the outside and ultra-pricey on the inside. At my first meeting to discuss pasta-sauce packaging—with the two brothers from the Abruzzi who had started this restaurant twenty years earlier, along with new owners who were poised to take the reins—I felt as if I were in a scene from the film *Big Night.* The brothers had brought their wives along, one of whom was lamenting that since the sale of the restaurant, her husband didn't know what to do with himself anymore, so he just kept making pasta. "He gets up every morning and he just *has* to make pasta. Not just for his family but for fifty, one hundred people!" I was moved by the former restaurateur's passion for his art and decided to dedicate the package design to him. The photograph on the hangtag shows the chef at age fourteen, at his first job in Italy waiting on tables. The logotype was an upgraded version of the original scrawl (page 177) used for both the logo and the menu (which never changed). The bonnet on the pasta sauce jar features additional hand-lettering inspired by 1920s Italian typography. To guide the clients along, I supplied detailed instructions for how to apply the custom-monogrammed lead seal to the elastic closure.

WINES
Red, white, and sparkling

---※---

MATT BROTHERS

There are many different versions of the Sfida label. Each time the blend formula changed, so did the design, which needed to be lettered for each incarnation.

I OFTEN FIND VERY CONFUSED-LOOKING MESSENGERS AT THE DOOR of my studio, stammering, "Um, I was looking for a design office. This looks like a *wine shop!*" Over the years, three clients have made it possible to ensure that something good to drink is always on hand.

Bartlett Maine Estate Winery's botanical-inspired labels were my first foray into the field.

Sfida, which means "challenge" in Italian, was an aptly named wine from Matt Brothers, since I somehow had to fit an enormous amount of text onto the front label. I decided to take advantage of a difficult situation and make the design a celebration of its typography, which was all hand-drawn in red and black Italian deco–inspired letterforms created to fit the label's very specific proportions. Bosco del Grillo provided me with the long-awaited opportunity to make a label inspired by early nineteenth-century French and Italian designs. Since the cost of a die-cut was prohibitive, I chose a black background that I hoped would disappear when seen from a distance. For Terrazzo Prosecco, our goal was to make the type look effervescent: the result was a hand-drawn script and border printed in subtle metallic colors.

Calea Nero d'Avola, a red Sicilian wine from Polaner Selections, called for study of the poster designs of *stile Liberty*, the Italian art nouveau period. A change of name and color palette accommodated the white wine that followed a year later. Tratturi, from the Salento region of Italy (the heel of the boot), uses a pattern created to evoke the *trulli*, or cone-shaped huts, that are emblematic of that region. The logotype was hand-lettered in the style of the 1930s. Il Conte red and white completed the lineup, again using deco-inspired lettering and ornamentation.

POLANER
SELECTIONS

Inspired by Italian typographic design from the early part of the twentieth century, these wine labels are virtual mini-posters.

BARTLETT
MAINE ESTATE
WINERY

Determined to produce wine in Maine (a state not known for viniculture), the Bartletts make their wine from every fruit except the grape. An archive of botanical prints from 1910 gave me every fruit needed—even loganberries—except for wild blueberries, which had to be picked at my country house, rushed back to New York, photographed in black and white, and retouched (this was the pre-Photoshop era) to match the series.

BARTLETT

Wild Blueberry Wine
oak-dry

Alcohol 11.5% by Volume

BARTLETT

Strawberry Wine
sweet

Alcohol 11.5% by Volume

BARTLETT

Mead Wine
dry

Alcohol 11.5% by Volume

BLUE Q
Totes with a conscience

The Alpha Shopper (at right) was designed in the hopes of attracting male buyers, who for some inexplicable reason seem to think that carrying a tote to save the environment is not a particularly manly thing to do.

THE ONE TIME I SENT OUT A PROMOTIONAL MAILING (ADDRESSED by hand, which may explain why I got no further than the *B* names in my Rolodex), I received one response—from Mitch Nash, of Blue Q. Everyone at the studio could sense that something unusual was afoot when a fax was coming out of the machine and it wasn't offering a free trip to Bermuda! As I watched the page slowly emerge, a flamboyant script (done in Mitch's signature #2.5 pencil) came into view. It read: *Whoever sent us this postcard… has wicked FABULOUS handwriting!* And further down, in tiny writing in the corner: *(Is that you, Louise?)* Thus began my working relationship with Blue Q, a company specializing in quirky giftware. Every new job starts with a series of multipage faxes written in Mitch-ese, with notes, musings, and general inspiration, followed by a few phone conversations. Then, after several rounds of sketches, we have a design. The imagery for the projects is drawn from my archive. For the da Vinci tote and pouch, Leonardo's *Ginevra dei Benci* was mated with letterheads from the late 1800s. The World Shopper, a consistent bestseller, features Dutch labels from the 1940s. The Perfume Shopper is a montage of French deco labels. And the Madonna Shopper is the iconic Filippo Lippi image juxtaposed with patterns and shades of hot pink. The shoppers are made from ninety-five percent post-consumer waste. The travel mug was inspired by a *pasticceria* pattern, and upon careful inspection reveals the client's and designers' names.

ABCDEF
GHIJKL
MNOPQR
STVXYZ

122

The World Shopper is indeed well traveled. The design is composed of a collection of mid-twentieth-century Dutch labels I had bought in France. After I brought them back to New York, I sent the files to Blue Q in Pittsfield, Massachusetts, which had the bag produced in China. I even took the finished product on a trip to Holland, where at the airport a Dutch designer asked where to buy one, since she had never seen those labels before.

IDENTITIES

Question: what is the difference between a logo and a brand? Answer: about $500,000. I create logos, not brands. I prefer to work with smaller businesses, run by owners whom I genuinely like and whose products I respect. (Admittedly, every now and then a bigger company crashes the gate, but not often.) Nothing is more gratifying than to witness the success of a startup company, knowing that the design might have played even a small role in it. Here is my perfect brand-name day: dressed in Ilux, I have breakfast courtesy of Irving Farm Coffee Company and American Spoon, I walk to the studio carrying a Blue Q tote, work until it is time for a pick-me-up of Q.bel chocolate or a passion-fruit sorbetto from L'Arte del Gelato, have a glass of Calea Nero d'Avola at *aperitivo* hour, and stop in at the Mermaid Inn for a lobster roll on the way home. Small businesses make good business.

№{212}

544-0986

TIFFANY & CO.
A mark for a jewel

---※---

I love to design monograms, yet they never fail to present a challenge. No matter what the initials happen to be, they always seem to be the wrong ones at the start of the design process. By the time the job is finished, and the letters are cohabitating comfortably, the emblem betrays not the slightest hint of a struggle.

AN ASSIGNMENT FROM TIFFANY & CO. WAS AT ONCE EXCITING AND daunting: to design a custom monogram for the venerable jewelry giant—one that could be used in a size as small as the winder of a man's watch, or as large as a construction shed. Tiffany & Co. had just implemented a new logo design, and a monogram was needed to complement the identity.

Art director Karen Silveira supplied helpful reference materials from Tiffany's impressive graphics archive, sending me off on fascinating time travel. Somehow I had to translate this historical elegance into contemporary form. Using classic typefaces such as Garamond, Bembo, and Trajan as points of reference, I set to work sketching out various configurations of the initials. I needed to make some basic decisions immediately: should the components be a *T* and *C*; a *T*, *&*, and *C*; or a *T*, *&*, *C*, and *o*? We attempted all three. The ampersand was by far the biggest challenge: I came to the conclusion that it should neither match the logo exactly nor appear too different. I had never realized just how many different styles of ampersands there are until I studied them extensively for this project.

For the initial presentation, I made a small book showing five options for the monogram design, one per page, in both large and small formats. The ampersand was the primary element of each, wrapping around a central *T*. My immediate favorite was the version with the *C* and *o* on either side of the ampersand. Fortunately that was preferred by Tiffany as well, and after one round of minor tweaks, a monogram was born. It was rewarding to see it as a watermark on the company letterhead. How often does a designer have the chance to create a watermark?

1 *Preliminary monogram explorations in pencil*

2 *A small book was made for the initial presentation, showing five different monogram options in both large and small formats.*

MONOGRAM B

③ *The lower left option was chosen for further development. Ultimately, I supplied a number of different versions of the final logo, customized according to size and application.*

ILUX
Chic Italian hosiery

Ilux was enamored of the Bolivar logo (page 56), and since the restaurant had already closed, it seemed fair to design this typographic cousin.

WHEN ILUX CAME TO SEE ME WITH ITS LINE OF LUXURIOUS Italian cashmere socks and tights, I was an immediate convert. Who could resist these stylish and seductive treats for feet? It was clear that this product required a distinctive identity. I suggested a woven fabric label instead of the traditional paper label used by every other manufacturer (and after the Metro Grill project [page 42], I had the perfect source already lined up). Fortunately, the clients were willing to bear the extra expense to showcase their product, and the investment paid off—Ilux was soon noticed everywhere and has since expanded its line to intimate apparel. To my own surprise, the color palette of black, cream, and green manages to coexist nicely with every color combination in the line—and there are many, many different hues and patterns to compete with.

When Ilux launched a line of intimate apparel called Skin to Skin, I designed a box with a big cutout circle dotting the *i* of Ilux, giving a glimpse of the color and texture of what lay inside. The same printed box was used for all of the products. On the back, instead of a cutout, the dot over the *i* was turned into a black sticker listing product details, along with a line illustration of the garment.

The ultimate honor? To have a pair of socks named after me. Look for the exquisite cashmere knee-highs called Fili (which also happens to mean "threads" in Italian).

HANKY PANKY

The thong worn 'round the world

Details of Hanky Panky's annual sample sale in New York are more eagerly anticipated than the Oscar nominations.

I REDESIGNED HANKY PANKY'S IDENTITY IN 2001, JUST IN TIME FOR the company's launch into lingerie prime time. When the *Wall Street Journal* ran a front-page story on the infamous 4811 (America's bestselling lace thong), Hanky Panky soared to national attention. For many women, it has become as indispensable as lipstick.

The redesign couldn't have come a moment too soon. The original logo (page 171), which had been in use for nearly twenty-five years, was somewhat juvenile for Hanky Panky's clientele. The girlish 1950s-style script, with a frilly border, needed to be traded in for something more contemporary. With a name like Hanky Panky, an overly sweet logo seemed redundant. Instead, a simple, elegant hand-lettered type treatment with linking *k*'s seemed appropriate for this smart and sophisticated line of lingerie, nightgowns, and sportswear. Although the letterforms were derived from an early-1930s alphabet by Samuel Welo, they maintain a fresh aesthetic. The logo appears on everything from chemises to camisoles and bikinis to bodysuits. Packaging for lingerie wash and individual thongs developed the brand further.

My favorite way to see the thong packaged is the rose bouquet—a dozen long-stem roses in a tissue-filled box. When a straight pin is removed from each "flower," a red lace thong is unfurled.

PAUL TANNERS, DDS

Dental work

---※---

Why are there certain professions, such as law or dentistry, that seem immune to graphic design? A good logo can change the perception of these imposing businesses.

WHEN I WAS GROWING UP, OUR FAMILY DENTIST HAPPENED to have his office directly across the street, and every day walking home from school I would hear the piercing sound of the drill through his open window. Each time, I would cringe at the thought that one day soon I would have my turn in that dreaded chair. I have never been fond of dentists. At least, not until I met Dr. Paul Tanners, or the King of Crowns, as he is sometimes called. This Madison Avenue prosthodontist, who offers state-of-the-art technology, a gracious staff, and a complimentary foot massage with every visit, needed an identity as distinctive as his practice. I asked to look at examples of his colleagues' business cards, and they were quite appalling. One was set in Comic Sans. Who would want to trust his pearly whites to someone with that kind of taste in type? Dr. Tanners deserved better. His elegant monogram, inspired by eighteenth-century designs, includes a subtle nod to his signature dental restoration work by featuring a tiny ornamented crown.

It's impossible to ignore the reminder card, printed on heavy Crane's cream cover stock, with a glowing tooth to dot the *i*. Who has ever enjoyed getting a postcard for a teeth cleaning? Now, you actually can.

GRASSROOTS
All-natural typography

---※---

The logo for Grassroots was designed in tandem with the font. The letterforms were placed in a banner that was integrated into an evocative illustration of a bunch of leeks floating on a pastoral landscape.

OFFERING A COMPLETE HEALTH EXPERIENCE UNDER ONE ROOF, Grassroots Natural Market, an 8,000-square-foot space in SoHo, was designed like a French marketplace, with gleaming copper accents and ornately carved celedon-colored pillars. This was the first project I worked on with the architectural firm Bogdanow Partners (we would later team up on many restaurants) and is a perfect example of collaboration at its best. Larry Bogdanow showed me a sketch of what he described as "a country store." The facade's squarish, protruding columns allowed me to design vertical typography that called out special features such as vitamins, homeopathy, and salad and juice bars. We decided that the lettering would be back-painted onto glass and mounted on the columns, and I set out to research typefaces. A favorite book, a reproduction of a French sign painter's manual from the 1920s, had a sample of what I had envisioned: a bold serif letterform with three different drop shadows. The alphabet was painstakingly created in Illustrator over the course of several weeks. As time-consuming as that was, the worst was yet to come: finding a living sign painter. An exhaustive search led to the discovery of Tony Garcia, a third-generation lettering artist from New Mexico. After a test letter was applied to the glass, the vertical panels were ordered and painted exquisitely (in addition to the Grassroots sign above the door). The logo was silkscreened onto the front windows, and more signage was created for the interior. It was a sad day for all when, a number of years later, a Club Monaco moved into the space. The signs were removed, never to be seen again.

GRASSROOTS
NATURAL MARKET

① *A custom font was designed for this natural-foods market based on a specimen found in a French sign painter's manual. Each letter had three distinct drop shadows.*
② *For years, my staff had strict instructions: in the event of a natural disaster, grab this book first.*
③ *The storefront, on Broadway in SoHo, featured the font back-painted onto glass and mounted onto three sides of each column.*

AROMATHERAPY
HOMEOPATHY
COSMETICS
SALAD BAR
JUICE BAR
VITAMINS

NATURAL **GRASSROOTS** MARKET

VITAMINS · JUICE BAR · HOMEOPATHY · SALAD BAR

RUSK RENOVATIONS
Constructing an identity

---※---

I always enjoy having the opportunity to design a logo as an object. The Rusk logo, like the pencil for Bespoke Education (page 180), offers the extra tactile quality that makes an identity all the more memorable.

WHEN I FIRST MET WITH MARY KOCY OF RUSK RENOVATIONS TO discuss a logo, I immediately thought of using a ruler or measuring tape. In my mind's eye, I saw one of the old, folding, wood-and-brass varieties, which I attempted to describe to her. Not only did she know what I was talking about, she actually had one at her house upstate. Once she managed to locate it, we scanned it and used it as the basis of the Rusk logo. The fine, very specific style of the numerals was translated into the letters of the Rusk name, and two different typefaces were used for the rest of the copy. The final digitally manipulated result is an accurate emblem of this very high-end construction company's time-honored techniques, fine craftsmanship, and attention to detail, and was applied to business cards, stationery, hats, T-shirts, and—at twelve feet long—the trucks.

The old adage "Measure twice, cut once" never had such resonance.

143

CRANE & CO.
A river runs through it

---※---

When I presented the monogram to Crane & Co., the group of five representatives had a difficult time arriving at a consensus. We scheduled another meeting, this time at my studio, where I told them that we couldn't leave the room until a decision was reached. Finally, we held a secret ballot and, incredibly, they unanimously agreed.

WHAT DO PAUL REVERE, ELEANOR ROOSEVELT, AND THE QUEEN Mother have in common? They have all used Crane & Co. stationery. This storied, eight-generation paper company synonymous with fine materials and exquisite craftsmanship needed a monogram that could be implemented across many communication platforms, products, and materials—from the website to stationery and wedding invitations; on paper, cloth, and metal. Moreover, the mark needed to reflect the firm's history while representing a forward-looking luxury brand. I recommended that their logotype would also greatly benefit from an overhaul. Why buy a new dress if you are going to wear it with the same old pair of shoes? The existing logotype, which was simply a horizontally scaled version of Trajan, had to be adjusted to work in conjunction with the monogram yet also stand on its own. In addition, we considered how the monogram could apply itself to a maker's mark—an iconic, abstracted version that could easily be recognized as the symbol of the Crane & Co. brand.

Four distinctive monogram treatments were presented. Once again, I was grateful to have an ampersand to work with. As with Tiffany, we provided a choice of initial combinations: *C*, *&*, *C*, and *o*; or *C*, *C*, and *o*; or *C*, *&*, and *C*. The Housatonic River in Dalton, Massachusetts, where the Crane mill is located, provided inspiration for the natural flow of the nesting *C*s and ampersand. Each monogram was shown with a corresponding logotype, none of which was radically (or perhaps even noticeably) different from the previous logo. But, as with many makeovers, the perception of renewed elegance made all the difference.

144

MORE LOGOS

Typographic portraits

———✶———

Although Le Monde's owner had a habit of naming his properties after French newspapers, he had no interest in a masthead-style logo. Instead, I used an alphabet reminiscent of Parisian hand-painted bistro signs.

I WAS ONCE ASKED BY AN INTERVIEWER, "WHAT IS THE MOST CHALLENGING project you have ever had to design?" My answer: "Whatever job I am working on *right now*." Logos, in particular, are never, ever, easy. Each time is like childbirth: the delivery is excruciating, yet after it is over, I am ready for the next. A great logo appears effortless—and is, of course, anything but. Setting a word in a font does not make it a logo. Rather, a logo is a typographic portrait—the face of a business. I talk to clients at length, learning everything about who they are and what is important to them, and then translate that into type.

I approach logo design in much the same way that I designed book jackets for so many years. After doing extensive visual research on the subject, I sit down with a tracing pad and

146

#2 pencil, and I start sketching. I write the name over and over, letting it speak to me. Many pages later, it will have evolved from an amorphous jumble of letters to a more precise design. At that point I am left with a typeface that does not exist, and it will need to be hand-lettered. I will gather specific reference, make a more informed sketch, and have it transformed on the

computer. The biggest challenge is to make the logo look as though it weren't created digitally. The logos I have designed have been composed in many ways: from actual hand-lettering, from pieced-together letterforms from old type books, or from objects and images scanned and altered digitally. Each new project presents its own set of challenges. But that's what makes designing logos so irresistible.

PIGALLE

French restaurant in New York's theater district

OMBRA KITCHEN · WINE · BAR

Italian restaurant and wine bar in the Borgata Hotel, Atlantic City

METROMARCHÉ

French bistro in New York's Port Authority Terminal

ecco

*An imprint of
HarperCollins publishers*

1251 AVENUE OF THE AMERICAS
AT 49TH — MARITIME — AT 49TH
NYC 10020 • TEL 212 354 1717

*Midtown Manhattan
seafood restaurant*

METROPOLE

*French restaurant in New York's
Flatiron district*

Upper East Side independent bookstore

French bistro in Manhattan

Seafood restaurant in Westport, Connecticut

Tribeca restaurant

the Harrison

355 GREENWICH ST.

AT HARRISON ST.

NEW YORK, NY

10013

MĀLAMA

Hawaiian day spa

Seaside hotel and restaurant in Long Beach Island, New Jersey

Casual Italian restaurant in the Borgata Hotel, Atlantic City

*Upper East Side
Italian restaurant*

Upscale Italian restaurant in the Borgata Hotel, Atlantic City

MAISON

Midtown Manhattan French bistro

BELLI

Caterer specializing in Italian cuisine

Boston seaport restaurant

*Mediterranean-inspired hotel in
Greenwich Harbor, Connecticut*

biella

COLLEZIONE LUXE

Hosiery importer

HYPERION

Book publishing division of Walt Disney Company

Coffee roaster and cafe in Hawaii

*New York real estate broker
specializing in townhouses*

Floral designer in New York

Restaurant in New York's Union Square

Tocqueville

BLOUNT PARK

Cultural park in Montgomery, Alabama

Salumeria in Fort Worth, Texas

Parisian bistro in New York

BEFORE AND AFTER
Makeovers, large and small

---※---

For a designer, the ultimate achievement is to see a business succeed after a graphic overhaul—to go from an eyesore to a thing of beauty. Large or small, a good makeover can breathe new life into a tired brand.

Sometimes a logo can be viable for the life of a company and never appear dated or stale. Frequently, however, even the most established logos can benefit from an update. *Good Housekeeping* approached me as its iconic Seal of Approval was about to turn one hundred. Over the course of the century, the seal had gone through many redesigns—roughly one every ten years—and each one typified its decade. The first incarnation, from 1909, was clearly the best, and the last one, sadly, represented everything we try to forget about graphic design in the 1990s. A clean, timeless design was needed.

One thing that I have learned from makeovers, whether Sarabeth's or *Good Housekeeping* or American Spoon, is that a lot can be changed as long as one or two elements stay the same. In this case, we retained the oval and the star. The seal designs were presented to a group of eight women who had responded with great enthusiasm at our initial meeting to copies of my limited-edition letterpressed promotional books (page 198). Based on their reaction, I decided to make a similar book (though not in letterpress) to give to each of them as part of the presentation. Miraculously, although there were many subtle alternate versions, a consensus was quickly reached. Later, when the new seal was unveiled on *Today*, there was an apparent mixup: the 1990s version was shown as the new one and mine as the old one. I took it as a compliment—the logo was timeless enough to seem as though it had always been there, just as I had intended.

After

· GOOD ·
HOUSEKEEPING

LIMITED WARRANTY to CONSUMERS

Since ★ 1909

REPLACEMENT or REFUND if DEFECTIVE

Before

LIMITED WARRANTY TO CONSUMERS
Good Housekeeping
Promises
REPLACEMENT OR REFUND IF DEFECTIVE

After

Sarabeth's®

Legendary Spreadable Fruit

Orange Apricot Marmalade

Net Weight 18oz (510g)

Before

Orange-Apricot Marmalade

Sarabeth's
'Spread the Word'
Legendary Spreadable Fruit
NET WT. 18 OZ. (1 LB. 2 OZ.)(510G)

After

hanky
panky

Before

After

MANHATTAN FRUITIER

Before

MANHATTAN FRUITIER

After

Before

After

Before

After

L'Arte del GELATO™

Fresco ogni giorno

Before

After

IRVING FARM

COFFEE COMPANY

Before

176

After

Il Mulino
— NEW YORK —

Before

Il Mulino
FINE ITALIAN CUISINE

After

AQUA FORTÉ

for a PERFECT SMILE

NATURAL SPRING WATER *with* FLUORIDE

Before

After

Before

After

BESPOKE EDUCATION **.COM**

Before

Tim Levin Tutoring

After

Before

BELLA CUCINA

Artful Food

DESIGNER/AUTHOR

Upon establishing my own design studio, I learned two important life lessons: never depend on any one type of work or client, and never sit and wait for the phone to ring. Every designer needs to develop personal projects in order to find a unique voice. I started with the subject closest to my heart, Italian art deco, which evolved into a series for Chronicle Books and into more books with my husband/collaborator Steven Heller. After creating a limited-edition Italian travel guide for designers, I was encouraged to expand this concept into books for the Little Bookroom. The *Senior Library* annual for SVA provided the occasion to design a book as an over-the-top box of chocolates, and the 150th anniversary of the unification of Italy afforded the opportunity to design a series of covers for ten novels that helped shape a nation.

BOOKS ON DESIGN AND STYLE

A passion between covers

It took significant arm-twisting, but Chronicle Books finally allowed me to place their required spectacles logo onto the image of the smoking woman on the spine of the book.

IN 1989 STEVEN AND I COLLABORATED ON OUR FIRST BOOK, ON Italian art-deco graphic design. I drew on materials collected over years of combing flea markets, and I also traveled to Milan and Parma to meet with corporate archivists at companies such as Campari and Lazzaroni, as well as private collectors. The result was the first of a series of eight books to be published by Chronicle Books on art-deco design and typography: Italian, Dutch, French, British, Spanish, German, American streamline, and deco type. Steven and I selected the work together. He wrote the text, and the books were designed at my studio, following two simple rules: design a different display type for each book, based on a representative image (Jonathan Hoefler generously created the font for *Italian Art Deco*, while the remaining titles were done in-house), and always feature an image of a woman on the cover. (This posed a small problem when designing *German Modern*, where no representative female was to be found among the images. Apparently the Germans preferred glorification of the male form. Eventually we managed to exhume an appropriate redheaded *fräulein*.)

The series was a success, and after a healthy run it found its way to publishing remainder purgatory. Selections from each of the books (with the exception of *Streamline)* were given new life in a hardcover compendium, *Euro Deco,* which is, happily, still in print.

Cover Story, Typology, Design Connoisseur, Counter Culture, and *Stylepedia* followed. Our latest and most ambitious collaborative effort to date is *Scripts: Elegant Lettering from Design's Golden Age*, a 352-page extravaganza of cursive types from America, England, France, Italy, and Germany, all culled from our drawers, walls, and many treks to Europe.

This book presents an eclectic assortment of graphic design artifacts; type, letterheads, logos, and ornaments were culled from type-foundry books, specimen sheets, alphabet books, and advertising from the early 1900s.

The intent of this book was to put type in a visual and historical context. One hundred fifty years of international type design were represented, from nouveau elegance to scrappy grunge style.

189

Complete with thumb tabs, this is a handy, cross-referenced desk guide to the kaleidoscope of design, both high and low—from the first Santa Claus to appear on a Coca-Cola bottle to the camouflage T-shirt, from agit retro to Zanol.

OBEY THE GIANT

groups since the '60s. Fairey's original artwork was a grungy photocopy made from a found newspaper ad. The text he used, "André the Giant has a posse," referred to Fairey's fellow skateboarders, who traveled in cliques called posses and decorated their boards with corporate logo decals and stickers. Fairey's satirically faux logo managed to catch on. Soon it grew into a "statement" with universal social implications.

Designer: Shepard Fairey
Poster, 2005

By taking something absurd with no intrinsic value, "like an athlete from a bogus white-trash sport, and elevating it into an icon," explains design critic Michael Dooley about Fairey's intentions, "he's exposing consumer culture's susceptibility to propaganda." He prefers using an oblique approach because he hates stuff that's too self-righteous. "Rather than subject people to sloganeering, he wants them to have their own epiphany."

What started as an art school prank has turned into a style, and has become a single-minded obsession. Every weekend Fairey posts stickers, sprays on hand-cut stencils, and wheat-pastes posters that convey pitches that subvert common advertising. Billboards are a favorite venue for hijacking messages. He once "hijacked" a dozen Sprite "obey your thirst" boards up and down the California coast, obliterating everything but "obey" and turning them into Giant boards. He believes that any unadorned surface is fair game for his art, which pays homage to the Dadaists or Situationists.

What began as antiadvertising—Giant was a silent spokesperson without a product—has now become its own style and brand, complete with a line of T-shirts, hats, and backpacks. Fairey says, "People justify buying some new $80 shampoo because they need to wash their hair, even though they could get the same thing at the 99¢ store. But when they buy the Giant shirt it peels back all the veneers people use to shroud themselves in justification for all the other stupid stuff." He doesn't seem to worry about the contradictions inherent in transforming the antiestablishment into an establishment all its own.

SEE ALSO *Agit Retro, Chantry, Dada, Kodalith, Psychedelic, Skateboard*

OBJECT POSTER

In the beginning of the early nineteenth century commercial advertising relied on words because pictures were just too costly to reproduce. Ideas and messages were communicated through words set in wood or metal typefaces, printed in multiples, and posted on any empty surfaces. Walls, fences, and hoardings were covered with bold letters announcing miraculous patent medicines, derring-do entertainers, and honest-as-the-day-is-long political candidates. In fact, there were so many words that printers, the craftsmen fundamentally responsible for producing advertisements, could garner attention only by using the most raucous of letterforms. Larger, bolder, decorated letters were akin to screaming hawkers. But amid the cacophony of Tuscans, Latins, Egyptians, and novelty faces, a poster or broadside had to be more than just loud, it had to jump off the wall, onto the street, and into the public's consciousness.

Imagery was key. With the advent of chromolithography during the late nineteenth century a sea change in advertising and graphic design occurred. The reproduction of colorful tonal pictures gave birth to popular art that not only persuaded but entertained. With this new technology artists developed looser styles

Designer: Lucian Bernhard
Poster, 1914

A compendium of more than two hundred American illustrated magazine covers from the first half of the twentieth century, which not only sold periodicals but were works of art in themselves.

Some of the most fascinating American and European advertising of the 1930s, 1940s, and 1950s comes from a lost genre of mini-mannequin countertop displays.

193

From an Italian schoolchild's 1923 composition book to seductive French perfume labels, this book is a celebration of all things cursive. At a book stall along the Seine in Paris, I unearthed a delightful series of French sheet music (opposite).

194

LOGOS A TO Z
Alphabetical identities

—✶—

These promotional books were printed as a limited edition in letterpress and four-color offset. The jackets are made from Fabriano paper stock. All are individually hand-numbered on the flap. I have always maintained that if anyone ever were to throw one out, I would feel it like a knife in my heart.

ONE DAY IT OCCURRED TO ME THAT I HAD DESIGNED A LOGO FOR almost every letter of the alphabet—from restaurant Au Café to fashion designer Zelda. (If it weren't for Zelda, I don't think I ever would have thought about it.) Thus was born the first volume of *Logos A to Z*, which included twenty-six logos (although admittedly not every letter of the alphabet was included; some letters were duplicates). I was soon on a quest. *More Logos A to Z*, published two years later, included several of the elusive letters, and by the third volume, I was unapologetically offering a discount to any new business starting with the letters *Q* or *Y*. Bahram Shirazi was thoughtful enough to name his company Q.bel based on my needs. And when Yes We Can, a chefs' collaborative, asked for an identity, I jumped at the chance. Having reached that goal, I have long since prepared files to send to press for *100 Logos A to Z*. But I just can't bear to do it—I keep waiting for one more perfect logo.

A DESIGNER'S GUIDE TO ITALY

An Italian love letter

———✳———

I went to a desolate part of Long Island City to personally show the original ex-votos to the die-cutter, in order to explain the intricate embossing and debossing. To have left them there—particularly the breasts—would have been out of the question.

"YOU DON'T KNOW ME, BUT I AM A DESIGNER AND I'M TAKING MY FIRST trip to Italy, and I heard that you know all the interesting places to go." I receive calls like this all the time from complete strangers seeking advice. In this role as the unofficial travel guru of Italian design, I started to amass stacks of custom itineraries by city. The faxes morphed into e-mails, and finally one day I decided to put them into a little book. When I suggested to my longtime printer, Mike Cohen of Darby Litho, that we create a limited-edition joint promotional piece, he was enthusiastic.

The premise was simple: in Italy, good design is everywhere, in places you would least expect. This sixteen-page celebration of vernacular design takes the reader on a trip to the market, with a tipped-on orange wrapper re-created on parchment; to a newsstand, with headlines of the day printed in letterpress; and to a *pasticceria*, with an engraved, tipped-on bag. (Reach inside for a handful of die-cut marzipan fruits.) The showstopper spread incorporates reproductions of ex-votos, printed in duotones on metallic paper, then embossed, debossed, die-cut, and tipped on. A directory lists museums, flea markets, and places to find the best signage. Inserted into the back flap is a tiny *Traduttore Tascabile* (Pocket Translator), which includes a guide to hand gestures, useful phrases to help procure a wrapped orange from a fruit vendor, and tips on how to negotiate a deal at the flea market.

IL MERCATO

IT IS WELL WORTH a trip to Bologna, the gastronomic capital of Italy, just for the open-air produce markets. The dazzling visual feast you'll find there includes stalls that feature mile-high mounds of oranges, only a few of which are displayed in their paper wrappers. You'll need to explain to the vendor that you would like one of those because they are so extraordinarily beautiful. This can be a delicate negotiation, although as always in Italy, a little flattery goes a long way.

IL PASTIFICIO

ITALIANS MAKE A SPECIAL art of creating pasta in original shapes, then giving them unexpected sobriquets. Who could resist a hearty helping of priest-chokers? When in Rome, be sure to drop by the Museo Nazionale delle Paste Alimentari, a shrine to Italy's signature dish, and then head straight to the nearest trattoria to experience culinary history for yourself.

At Bar Daria in Florence, the exuberant Valerio is famous for his *cappuccino firmato* ("signed" cappuccino). He deftly piles the steamed milk on top of the espresso, then places two knives in a "V" over the cup like a stencil, sprinkles on cocoa, and *ecco*—an enticing beverage emblazoned with his initial. ¶ In Italy, everyone is a graphic designer, and graphic design is everywhere. ¶ A *contadino*'s signature haystack graces each country field, while in the city, every shop sign is a work of innovative typography, from the *fornaio* to the *cartoleria*. Produce markets are resplendent showcases with mountains of fruits and vegetables, many in brightly-colored printed wrappers. If you prefer your comestibles slightly sweeter, you can buy a basketful of realistic edible imitations in marzipan form at any *pasticceria*. For Italians, design is as important and natural as eating. ¶ No wonder that so many graphic designers gravitate to Italy for inspiration. You'll be dazzled from the moment you enter this archeological site for design, with motifs from the Renaissance nestled next to Deco typestyling. This guide is an introduction to a few of the most spectacular places to revel in Italian visual culture. Don't settle, however, for the vicarious pleasures found herein; when in Italy you will find wonders of your own.

BUON VIAGGIO!

IL MERCATO DELLE PULCI

ITALIAN FLEA MARKETS can rival theaters for spectacular live entertainment. It is worth planning your itinerary around their rotating schedules. At Porta Portese in Rome, the vendors themselves put on performances that nearly outshine the objects for sale. They can also develop an almost parental attachment to their wares, and it would not be unusual for one of them to remember you and ask if your health — or at least your ailing body part — improved with the use of the *ex voto* that he sold you years ago.

la Città

INCARICO A CRAXI

TUTTE LE GRADUATORIE PER LA CASA

UNA NOTAIA TRUFFATA DA FALSO CHIRURGO

LOTTERIA SAN CASCIANO CHI SONO I VINCITORI

TUTTI I GIORNI A 300 LIRE

THE CIVILIZED SHOPPER'S GUIDE TO FLORENCE
Eighty shops in twenty days

---✦---

Thanks to the compact format of this guide, no one has to feel like a tourist carrying it around Florence. I've become so reliant on the maps that I keep the book tucked in a pocket at all times.

After designing many books for the Little Bookroom (page 218), particularly a guide to artisan shops of Rome, I suggested to the publisher that she develop it into a series—Florence or Venice, perhaps? Her response was immediate: "Florence, yes! And I want *you* to do it." I pointed out that I am neither a shopper nor a writer, but that seemed to be of little consequence. As it doesn't take much to get me on a plane to Italy to chat with shopkeepers and taste-test gelato, I was soon off on a new adventure. I have been visiting Florence regularly since the 1960s and thought I knew it well, but this was a different take on the city. I covered close to eighty shops and forty eateries in two visits of ten days each. At each shop I would interview the owner, fact-check contact information, take photos, and mark the location on the map (always the biggest challenge). Back at my hotel each evening, I would transcribe my notes into English, download the photographs, and make a plan for the next day. The best part was going back a year later to give finished copies to some favorite participants. Given the exuberant reactions from the *signori* upon seeing their likenesses in print, I realized that my next book should be called *Portraits of Male Shop Proprietors in Italy*.

ITALIANISSIMO
Italy, Fili style

Which patron saint is responsible for clairvoyance and laundry? (Santa Chiara.) Which division of the Italian police has uniforms designed by Pucci? (Polizia Municipale.) How do you buy an orange in the market with its wrapper still intact? (Employ a great deal of flattery!)

FOLLOWING THE PUBLICATION OF THE FLORENCE GUIDE, THE LITTLE Bookroom asked me to write a book on what I can only describe as "everything we love and sometimes love to hate about Italy." I enlisted the help of my friend Lise Apatoff, an American who has lived in Italy for thirty years. *Italianissimo*, or very, very Italian, is a loving look at the fifty quintessential things that Italians do best—from patron saints to pasta, gelato to gondolas. (*Fare la coda*, the art [or inability] of forming a line, was a personal favorite.) Some of the more abstract subjects were challenging to illustrate, but having a file of Italian ephemera was very helpful. Sheet music from the 1920s helped explain the second person singular, and a cover for an agricultural magazine served to illuminate the concept of superlatives and diminutives.

ITALIANISSIMO

The Quintessential Guide to What Italians Do Best

BY LOUISE FILI AND LISE APATOFF

IL FIGLIO ITALIANO

THE ITALIAN CHILD

PREGNANCY ELEVATES A WOMAN TO A NEW STATUS IN THE ITALIAN COMMUNITY, AND THE BIRTH OF A CHILD is an auspicious event with miraculous overtones, heralded by the placement of a large bow of pale pink or blue satin on the front door. The new *bambino* is duly cuddled, coddled, passed from hand to hand, overdressed, overfed, and overindulged. Parental love is demonstrated by dressing one's offspring as elegantly as oneself, as is evidenced by the proliferation of exquisite clothing shops for children throughout Italy.

Naturalmente, an emphasis on nourishment begins early on: mothers weigh their infants after each nursing to insure that they are eating enough. And while parents may be indifferent to what goes on in the classroom, they come out in droves to critique the school cafeteria offerings. Early bedtimes? Not with 8 pm suppers. *Bambini* are pampered in every way: none, or very few, have obligations to the household; daily chores, even bed making, are taken care of by parents and grandparents. Children will live at home, *serviti e riveriti* (served and revered) through college and until they marry, when somehow, miraculously, they manage to grow up—to indulge children of their own.

fifty-two ~ 52 ~ cinquantadue

I GESTI ITALIANI

HAND GESTURES

LUIGI TRUNDLES DOWN THE STREET CARRYING AN OVERSIZED WATERMELON. WHEN ASKED THE TIME, HE carefully sets the watermelon down, and then wordlessly shrugs his shoulders while throwing up his hands, signifying "I don't know." One gesture is worth a thousand words, and talking hands are an integral part of Italian vocabulary and communication. People on the street seem to talk to themselves and gesticulate as though bewitched; they are on cell phones, or *telefonini*, earnestly trying to make themselves understood while hampered by the use of words only. A father can give his son an emphatic "No!" to his request to use the car by tapping his front tooth with his index finger. The son will implore by pressing his palms together at chest level, rocking them back and forth, while the exasperated mother cuts the air with two fingers in a scissors motion to tell them to cease—all in a crystal clear, silent exchange.

IT STARTED IN NAPLES *A densely populated, noisy city* where life was lived in the street, Naples was instrumental in introducing hand gestures as a means of communication for all Italians. From upper stories of buildings, housewives would negotiate with vendors using sign language, then lower a basket with a rope for their wares. Residents from facing windows or balconies could easily converse above the din. And despite the very public aspect of Neapolitan life, a private conversation could be had in the crowded street through a mere exchange of glances.

fifty-six ~ 56 ~ cinquantasei

1 **INTESA** Agreed / Beware	2 **PIENO DI GENTE** Crowded	3 **TUTTO BENE** O.K.
4 **I GIURO** I Swear	5 **FAME** Hunger	6 **FINITO** Finished
7 **NIENTE!** No Good!	8 **IO NON SO NIENTE** It has nothing to do with me	9 **CI L'INTENDONO** Secret Liason
10 **LE CORNA** Cuckold	11 **NON ME NE IMPORTA** I don't care	12 **CHE VUOI?** What do you want?

208

LA DONNA ITALIANA

THE ITALIAN WOMAN

THE TWO MOST CITED FEMALES IN THE ITALIAN LANGUAGE ARE *LA MAMMA* AND *LA MADONNA*, BOTH of whom are invoked in moments of joy, fear, and rage: *"Mamma mia!" "O Madonna mia!"* While the traditional wedding toast may be *"Felicità e figli maschi"* (Happiness and male offspring), it is the woman—as confessor, disciplinarian, and procurer of favors, jobs, and pardons—around whom the family revolves.

CATERINA DE' MEDICI	1519–1589	Queen of France; brought ballet, the corset, fork, and tomato to the French
ARTEMESIA GENTILESCHI	1593–1653	Painter; won a lawsuit against her male teacher for sexual abuse
ELEONORA DUSE	1858–1924	Actress; first woman to be featured on the cover of *Time*
MARIA MONTESSORI	1870–1952	Educator; shown on the 1000 lire bill
ANNA MAGNANI	1908–1973	Actress; memorable role in *Open City*; won an Oscar for *The Rose Tattoo*
GAE AULENTI	1927–	Architect; designed the Musée d'Orsay in Paris
ORIANA FALLACI	1930–2006	Journalist and interviewer; humiliated Henry Kissinger

forty-five ~ 45 ~ quarantacinque

DARE DEL TU

THE TU FORM

WHILE THE ENGLISH LANGUAGE MAY HAVE ONLY ONE WORD FOR *YOU*, IN ITALIAN THERE ARE three: *tu* (familiar), *Lei* (polite) and *voi* (plural). *Tu* is used without question when addressing children, family, close friends, and lovers. Upon meeting a business associate, official, or elder for the first time, one must use *Lei* until instructed otherwise. You will be asked: *Potremmo darci del tu?* (Can we use the *tu* form?). It is considered impolite to assume informality unless agreed upon. One never stops using *Lei* with police, professors, and priests, and some women will spend the better part of their married lives addressing their mothers-in-law without ever daring to *dare del tu*.

> *In 1939 the Fascist party abolished the Lei form,* calling it a "witness…to the centuries of serfdom and abjection." Instead, they embraced the *tu* form, which expressed the "universal value of Rome and Christianity," and the *voi* form as "a sign of respect and of hierarchical recognition." A women's magazine of the time with the misfortune to be called *Lei* (which also means "she" in Italian) was forced to change its name to *Annabella*.
>
> During the anti-Mafia trials in Sicily in the late 1980s, tireless prosecutor Giovanni Falcone succeeded in eliciting testimonies from many Mafiosi due in part to his use of the *Lei* form, which was taken as a term of respect, while other magistrates patronized the defendants by addressing them with the belittling *tu*.

forty-two ~ 42 ~ quarantadue

RIZZOLI

The ten greatest Italian novels

———※———

On the publication date (exactly 150 years after the unification), a photograph appeared in an Italian newspaper showing the president of Rizzoli presenting this series to the president of Italy.

For the 150th anniversary of the unification of Italy, Rizzoli International Publications asked me to design a series of covers for the ten books that shaped the nation. The titles, all required reading at Italian schools, are classics of literature and are of major historical importance. I wanted the books to have an authentic yet timeless look, approximating the feel of a custom-letterpressed hardcover book with a cloth spine. The books needed to look like a series, yet each one demanded a distinctive treatment. As a result, most of the typography was based on historical wood type and wood ornaments, which were gathered at the outset. The colors red and black were common to the series, with each book having a unique background color from a palette of subtle tones. For added graphic and editorial appeal, the opening lines of each book's first chapter were included on its front cover.

Allowing the titles to guide me, I researched a direction for each book. The classic *I promessi sposi* (The Betrothed) evoked an Italian wedding document. For *Cuore* (Heart), a novel written in diary form as told by a nine-year-old primary-school student, I alluded to a composition book and handwriting guide from the period. *Ultime lettere di Jacopo Ortis* (The Last Letters of Jacopo Ortis) featured an envelope with an embossed wax seal, with a secondary font in the style of nineteenth-century handwriting. *Il piacere* (The Pleasure) was a celebration of calligraphic elegance, while the comparatively bleak title *Le mie prigioni* (My Prisons) was set in the most severe of bold wood types. *Le confessioni d'un Italiano* (Confessions of an Italian) allowed me to taper type to a point. The beloved *Pinocchio* required the most fanciful selections of type, and *Piccolo mondo antico* (Little Ancient World) accommodated the longest introductory text.

211

FEDERICO DE ROBERTO

VICERÉ

Giuseppe, dinanzi al portone, trastullava il suo bambino, cullandolo sulle braccia, mostrandogli lo scudo marmoreo infisso al sommo dell'arco, la rastrelliera inchiodata sul muro del vestibolo dove, ai tempi antichi, i lanzi del principe appendevano le alabarde, quando s'udì e crebbe rapidamente il rumore d'una carrozza arrivante a tutta carriera.

BUR rizzoli

IPPOLITO NIEVO

Le confessioni d'un italiano

Io nacqui veneziano ai 18 ottobre del 1775, giorno dell'evangelista san Luca; e morrò per la grazia di Dio italiano quando lo vorrà quella Provvidenza che governa misteriosamente il mondo.

BUR rizzoli

ANTONIO

Piccolo m

SOFFIAVA SUL LAG
INFURIATA DI VOLER
PESANTI SUI COCUZZO

usciva il primo fumo di pioggia. P
cappello a staio in testa e la gross
nervoso per la riva, guardava di
la mazza a terra, chiamando quell'

PREFAZIONE DI LUCIANO CANFORA

SILVIO PELLICO
LE MIE PRIGIONI

PREFAZIONE DI PIERLUIGI BATTISTA

EDMONDO DE AMICIS

Cuore

OGGI PRIMO GIORNO DI SCUOLA.
PASSARONO COME UN SOGNO QUEI TRE
MESI DI VACANZA IN CAMPAGNA! MIA MADRE MI

PREFA

Ug

CARLO COLLODI
LE AVVENTURE DI PINOCCHIO

C'era una volta...
– Un re! – diranno subito i miei piccoli lettori.
No, ragazzi, avete sbagliato.
C'era una volta un pezzo di legno.

BUR
rizzoli

GIOVANNI VERGA
I MALAVOGLIA

Un tempo i Malavoglia erano stati numerosi come i sassi della strada vecchia di Trezza; ce n'erano persino ad Ognina, e ad Aci Castello, tutti buona e brava gente di mare, proprio all'opposto di quel che sembrava dal nomignolo, come dev'essere.

BUR
rizzoli

PREFAZIONE DI ANGELO PANEBIANCO

Gabriele d'Annunzio
IL PIACERE

L'anno moriva, assai dolcemente.

Il sole di San Silvestro spandeva non so che tepor velato, mollissimo, aureo, quasi primaverile, nel ciel di Roma. Tutte le vie erano popolose come nelle domeniche di Maggio. Su la piazza Barberini, su la piazza di Spagna una moltitudine di vetture passava in corsa traversando; e dalle due piazze il romorio confuso e

PREFAZIONE DI ANDREA RICCARDI

ALESSANDRO MANZONI
I PROMESSI SPOSI

Quel ramo del lago di Como, che volge a mezzogiorno, tra due

SVA SENIOR LIBRARY
Visual confections for a graduating class

---✻---

When SVA students stormed the offices of the school's graphic design department in hopes of getting a copy of this book, they were surprised to find that there was no chocolate inside the box!

SHOWCASING WORK OF THE GRADUATING GRAPHIC DESIGN MAJORS, SVA's *Senior Library* is a lavish volume designed each year by a different faculty member. When Richard Wilde, longtime chairman of the department, invited me to participate in this project, he gave wonderful, succcint advice: "Do what you know." I knew precisely what to do: design it like a seductive box of chocolates.

The intricate design for the box was inspired by French typographic and decorative elements from the late nineteenth century. A custom foil sticker, monogrammed CD, and dyed ribbon were all color coded to match. This project was in full swing during a particularly hot spell in July, and as I ran around Manhattan buying up photogenic truffles, hunting down air-conditioned taxis, and praying that the chocolates wouldn't melt, I was again reminded of how art school had never prepared us for so many of the unexpected challenges of graphic design.

216

SENIOR LIBRARY
THE SCHOOL OF VISUAL ARTS
TWO THOUSAND AND TEN

THE LITTLE BOOKROOM
Stylish travel guides

———✻———

In addition to looking dimensional, the Little Bookroom guides feel good in your hand. The rounded corners of the covers are practical and distinctive.

THE DESIGN OF THE LITTLE BOOKROOM'S LINE OF SPECIALIZED and sophisticated travel guides for the real and armchair traveler was an opportunity to treat the book as an object and to explore the dimensional potential of a variety of subjects. Fortunately, most of the titles dealt with France and Italy, so not only was I the target audience, but I'd virtually completed the visual research. *The Patisseries of Paris* became an elegant pastry box with a gold seal and a flowing grosgrain ribbon; *Sew Chic*, a box of note cards based on 1930s French button cards collected at Paris flea markets, was designed to match the specimens inside. *The Authentic Bistros of Paris* was made to resemble typical French hand-painted restaurant signs; *The Traditional Shops & Restaurants of London* depicted a classic nineteenth-century-style label on a cylindrical tin; *Savoir Fare London* simulated colored chalk on a blackboard; *The Authentic Bars, Cafés and Restaurants of Buenos Aires* was designed to look like a hand-painted stucco wall; *Paris Chic & Trendy* featured the title on a garment label; the titling for *Chic Shopping Paris* displayed a card attached to a voluptuous salmon-colored bow; *Best Wine Bars and Shops of Paris* showed a wine label on a bottle with the Eiffel Tower in a discreet reflection; *Back Lane Wineries of Sonoma* approximated type stamped onto a wine crate; and the hand-embroidered *Shopping in Marrakech* cover required a trip to the trimmings district for sequins, fluorescent thread, and a Bedazzler. The pocket-sized guides to Florence and Rome featured a label secured with a dimensional seal; and the handy *Terroir Guides* each sported a different font and colored background texture.

COPYRIGHT PAGES
Redefining the banal

---※---

Until recently I had never had a shaped copyright page rejected outright. For a book on script typefaces, I proposed a big, loopy letter S typeset in a long curving line. Alas, the publisher felt that "a traditional treatment would be more discreet."

AFTER MANY, MANY YEARS OF DESIGNING BOOK INTERIORS, I CAN SAY that the least enjoyable design component is the copyright page. It usually appears on page four of a book—so that this dreadfully dull element is one of the first typographic treatments seen by the reader. All of the Library of Congress cataloging-in-publication data has to be typeset exactly as provided, line for line: ho hum. Finally, one day as I was designing a gardening book for Algonquin Books, I looked at the text formatted in centered lines and thought to myself, *If only I made a few adjustments, this could be a tree!* I tried it, and then showed it to my son—always my best critic, and two years old at the time. *He* got it, so I thought I was home free. But beware the wrath of the ever-vigilant copy editor, who was not amused. "No, no, no! It can't be done," she declared in a fit of apoplexy. My counterprotest, with supporting documentation from historical works by Guillaume Apollinaire, e. e. cummings, and F.T. Marinetti, fell on deaf ears. I finally won my case, thanks in no small part to Algonquin's forward-thinking publisher, Elisabeth Scharlatt. Once I had one acceptance under my belt, it was considerably easier to deal with the next publisher who tried to say no. At this point, I am pleased to have shepherded all these shapes into the publishing pantheon: a tree, a cat, a volcano, a heart, a chile pepper, a kidney bean, a teacup, a bottle, a wineglass, a headstone, a map of Cuba, the Eiffel Tower, the Twin Towers, a whisk, a baseball, and a Star of David.

Copyright © 1993 by Susan Kelz Sperling. Illustrations copyright © 1993 by R.O. Blechman. All rights reserved. No part of this book may be reproduced or transmitted in any form or by any means, electronic or mechanical Crown Publishing Group. Random House, Inc. New York, Toronto, London, Sydney, Auckland. CLARKSON N. POTTER, POTTER, and colophon are trademarks of Clarkson N. Potter, Inc. Manufactured in the United States of America. Design by Louise Fili. Library of Congress Cataloging-in Publication Data. Sperling, Susan Kelz. Lost words of love/by Susan Kelz Sperling.–1st ed, Includes bibliographical references. 1. English language – Obsolete words. 2. Love –Terminology 3. Love–Humor. I. Title. PE1667.S58 1993 422'.0207–dc20 92–3949 CIP ISBN 0517-58793-9 First Edition 10 9 8 7 6 5 4 3 2 1 including photocopying, recording, or by any information storage and retrieval system, without permission in writing from the publisher. Published by Clarkson N. Potter, Inc., 201 East 50th Street, New York, New York 10022. Member of the

Published by
Algonquin Books of Chapel Hill
Post Office Box 2225 Chapel Hill, North
Carolina 27515-2225 a division of Workman
Publishing Company, Inc. 708 Broadway New
York, New York 10003 © 1992 by Bill Neal. Introduction ©
1992 by Barbara Damrosch. All rights reserved. Printed in the United
States of America. Library of Congress Cataloging-in-Publication Data Neal,
Bill. Gardener's Latin: a lexicon/by Bill Neal.—1st ed. p. cm. ISBN 0-945575-
94-7 1. Botany—Dictionaries—Latin, Medieval and modern. 2.
Botany—Nomenclature. 3. Latin Language, Medieval and
modern—Dictionaries—English.
4. Plants—Quotations,
maxims, etc. 5.
Plants—Folklore.
I. Title QK9.N42
1992 581'.014—
DC20 92-2652 CIP
2 4 6 8 10 9 7 5 3 1
First Edition

Book design by Louise Fili and Lee Bearson

ORIGINALLY PUBLISHED BY THE TEA COUNCIL LTD

No. 9, The Courtyard, Gowan Avenue, London SW6 6RH. Every effort has been made to ensure the accuracy of this publication. However, the publishers do not hold themselves responsible for inaccuracies or omissions. The contents are believed to be correct at the time of going to press, but changes may have occurred since that time. © The Tea Council Limited 2001. Seventh edition, reprinted 2001. Acknowledgements: The Pump Room, Bath; Bruce Richardson, Elmwood Inn; Tai Tai Tea House; South Warwickshire Tourism; Lewes District Council; Harrogate International Centre; Scottish Tourist Board; Staffordshire Moorlands District Council; Wales Tourist Board; Norwich City Council; North Norfolk District Council; Devon County Council; City University, London: Richard Bailey. All rights reserved. No part of this publication may be reproduced, stored in a retrieval system or transmitted in any form or by any means — electronic, mechanical, photocopying, recording or otherwise — unless the written permission of the publishers has been given beforehand. Library of Congress Cataloging-in-Publication Data. The best tea places in England / Tea Council of UK.— 7th ed., reprinted. p. cm. Originally published: 2001. Includes index. ISBN 1-892145-16-2 (paperback) 1. Tearooms–Great Britain–Guidebooks. 2. Afternoon teas–Great Britain. 3. Tea. I. Tea Council. TX907.5.B7 B49 2001 647.9541–dc21 2002004107

COMPILED BY MELANIE ADAMS & JANE PETTIGREW DESIGN BY LOUISE FILI LTD

© 2002 The Little Bookroom 5 St. Lukes Place New York N.Y. 10014 (212)691-3521 fax (212)688-1169 editorial@littlebookroom.com

Copyright © 1996 by W. Park Kerr. Photographs copyright © 1996 by Ellen Silverman. All rights reserved. No part of this book may be reproduced or utilized in any form or by any means, electronic or mechanical, including photocopying, recording, or by any information storage or retrieval system, without permission in writing from the Publisher. Inquiries should be addressed to Permissions Department, William Morrow and Company, Inc., 1350 Avenue of the Americas, New York, N.Y. 10019. It is the policy of William Morrow and Company, Inc., and its imprints and affiliates, recognizing the importance of preserving what has been written, to print the books we publish on acid-free paper, and we exert our best efforts to that end. Library of Congress Cataloging-in-Publication Data: Kerr, W. Park. Beans / by W. Park Kerr. p. cm. ISBN 0-688-13253-7 1.Cookery (Beans) 2. Beans. I. Title. TX803.B4K38 1996 641.6'565–dc20 95-19032 CIP Printed in the United States of America First Edition 1 2 3 4 5 6 7 8 9 10 Book Design: Louise Fili Ltd; Design Assistant: Tonya Hudson

Copyright © 1994 by Art Spiegelman. All rights reserved under International and Pan American Copyright Conventions. Published in the United States by Pantheon Books a division of Random House, Inc., New York, and simultaneously in Canada by Random House of Canada Limited, Toronto. *The Wild Party* was originally published in 1928 by Pascal Covici. Copyright © 1928 by Pascal Covici, Publisher, Inc., Library of Congress Cataloging-in-Publication Data: *The Wild Party*: The lost classic by Joseph Moncure March drawings by Art Spiegelman p. cm. ISBN 0679-42450-4 I. Spiegelman, Art II. March Joseph Moncure. PS3 525. A58W5 1994 813'.52 — dc20 94-11682 Manufactured in the United States of America. Book design: Art Spiegelman. Type design: Louise Fili / Art Spiegelman. Typesetting: Leah Lococo. Production: Robert Sikoryak. First Edition 2 4 6 8 9 7 5 3 1

Text copyright © 1997 by Georgeanne Brennan. Photographs copyright © 1997 by Kathryn Kleinman. All rights reserved. No part of this book may be reproduced in any form without written permission from the publisher. Gerald Hirigoyen's recipe for Wild Mushroom and Goat Cheese *Galettes* is from his book *Bistro* and is published with permission from Sunset Books and Weldon Owen, Inc. Library of Congress Cataloging-in-Publication Data: Brennan, Georgeanne, 1943– Aperitif: recipes for simple pleasures in the French Style / by Georgeanne Brennan; photographs by Kathryn Kleinman. p. cm. Includes bibliographical references and index. ISBN 0-8118-1077-1 (hc)

1. Cocktails. 2. Appetizers. 3. Cookery, French. I. Title. TX951.B776 1997 641.8'74—dc20 96-28057 CIP

Printed in Hong Kong. Editing: Sharon Silva. Book Design: Louise Fili. Design Assistant: Mary Jane Callister. Distributed in Canada by Raincoast Books 8680 Cambie Street Vancouver, B.C. V6P 6M9 10 9 8 7 6 5 4 3 2 1 Chronicle Books 85 Second Street San Francisco, CA 94105 Web Site: www.chronbooks.com

Copyright © 1992 by David Pryce-Jones. Illustrations copyright © 1992 by Pierre Le-Tan. All rights reserved. No portion of this book may be reproduced—mechanically, electronically or by any other means, including photocopying without written permission of the publisher. Published simultaneously in Canada by Thomas Allen & Son Limited. Library of Congress Cataloging-in-Publication Data: Pryce-Jones, David, 1936- You can't be too careful: cautionary tales / by David Pryce-Jones; illustrations by Pierre Le-Tan. p. cm. ISBN 1-56305-156-7 1. American wit and humor. I. Le-Tan, Pierre. II. Title. PN6162.P78 1992 081'.0207-dc20. Workman books are available at special discounts when purchased in bulk for premiums and sales promotions as well as for fundraising or educational use. Special editions or book excerpts can also be created to specifications. For details, contact the Special Sales Director at the address below. Workman Publishing Co., Inc., 708 Broadway, New York, NY 10003. Manufactured in the United States of America. First printing October 1992 10 9 8 7 6 5 4 3 2 1 Design by Louise Fili and Lee Bearson.

The
first
edition of
*Death of Medi-
cine* was written by Wolfgang Weyers with a
foreword by A. Bernard Ackerman. The jacket
was designed by Louise Fili. Interior pages
designed by Louise Fili and Mary Jane
Callister / Louise Fili Ltd, New York
City. Published by Lippincott–Raven
Publishers and Ardor Scribendi. Printed in
offset lithography by Maple Press in York,
Pennsylvania. Printed on Finch Opaque and set in
Walbaum, Uniblock,
and Berliner
Grotesk.
1998

First published in the United States of America in 2010 by Rizzoli International Publications, Inc. 300 Park Avenue South · New York, New York 10010 www.rizzoliusa.com Text copyright © 2010 Sarabeth Levine · written with Rick Rodgers · Photography copyright © 2010 Quentin Bacon · All rights reserved. No part of this publication may be reproduced, stored in a retrieval system, or transmitted in any form or by any means, electronic, mechanical, photocopying, recording, or otherwise, without prior consent of the publisher. 2010 2011 2012 2013 10 9 8 7 6 5 4 3 · Printed in China · ISBN: 978-0-8478-3408-2 · Library of Congress Control Number: 2010927318 Project Editor: Sandra Gilbert · Assistant Project Editor: Tracey Zabar · Design: Louise Fili Ltd · Typesetting: 2 Eggs On A Roll

Published by
Algonquin Books of Chapel Hill
Post Office Box 2225 Chapel Hill, North
Carolina 27515-2225 a division of Workman Publish-
ing 708 Broadway, New York, New York 10003 ©1998
by Kenneth S. Robson. All rights reserved. Printed in the United
States of America. Published simultaneously in Canada by Thomas
Allen & Son Limited. Library of Congress Cataloging-in-Publication
Data Giamatti, A. Bartlett A great and glorious game: baseball writings
of A. Bartlett Giamatti / collected by Kenneth S. Robson. p. cm. ISBN
1-56512-192-9 1. Baseball—United States. 2. Baseball—Social aspects—
United States. 3. National League of Professional Baseball Clubs. 4.
Giamatti, A. Bartlett. 5. Baseball commissioners—United States—
Biography. I. Robson, Kenneth S. II. Title GV863.A1G52
1998 796.357'0973—dc21 97-32803 CIP Designed by
Louise Fili, Mary Jane Callister / Louise Fili Ltd
10 9 8 7 6 5 4 3 2 1
First Edition

Introduction, headnotes, and volume compilation copyright © 1998 by Literary Classics of the United States, Inc., New York, NY. All rights reserved. Printed in the United States of America. Some of the material in this volume is reprinted by permission of holders of copyright and publication rights. See pages 4-6 for acknowledgments. Published by The Library of America. Distributed in the United States by Penguin Putnam Inc. and in Canada by the Penguin Books Canada Ltd. Design by Louise Fili and Mary Jane Callister, Louise Fili Ltd. Library of Congress Cataloging-in-Publication Data. Writing New York: a literary anthology/Phillip Lopate p., cm. ISBN 1-883011-62-0. 1. City and town life–New York (State)–New York–Literary collections. 2. American prose literature–New York (State)–New York. 3. New York (N.Y.)–Literary collections. I. Lopate, Phillip, 1943- PS549.N5W75 1998 810.8' 032741–DC21 98-19332 CIP 10 9 8 7 6 5 4 3 2 1

COPYRIGHT © BY ELLEN WILLIAMS Design by Louise Fili Ltd. Cover: Jean Béraud: *La Pâtisserie Gloppe* (1889). Musée de la Ville de Paris, Musée Carnavalet, Paris, Giraudon/Art Resource, NY. Library of Congress Cataloging-in-Publication Data.

Williams, Ellen. Historic Restaurants of Paris/by Ellen Williams. p. cm. Includes index. ISBN 1-892145-03-0 (pbk.) 1. Restaurants France–Paris–Guidebooks 2. Restaurants–France–Paris–History. I. Title. TX9075.F72 P3795 2001 647. 95443'61–dc21 00-045317 ISBN 1-892145-03-0 Fourth printing, March 2002. All rights reserved, which includes the right to reproduce this book or portions thereof including photographs, in any form whatsoever, without written permission of the publisher. Printed in Hong Kong. The Little Book-room, Five St. Luke's Place, NY, NY 10014 t·212 691 3321 e-mail · book-room@rcn.com f·212 691 2011

Copyright 2001 Picture This Publications. Introduction copyright Vicki Goldberg. Reproduction copyright © by the artists. All rights reserved. No part of the publication may be reproduced, stored in a retrieval system or transmitted in any form or by any means, electronic, mechanical, photocopying, recording or otherwise, without prior written permission of Picture This Publications. Publisher: Marla Hamburg Kennedy. Editor: Kelly Padden. Editorial Assistants: Amalia Culp and Tal Schpantzer. Design: Louise Fili Ltd. Copy Editor: Steve Hamburg. Picture This Publications and Kennedy Boesky Photographs

TITLE PAGE: BURT GLINN

535 West 22nd Street, New York, NY 10011 Telephone 212.741.0963 Printed by the Stinehour Press, Lunenburg, Vermont. All proceeds will be donated to the Shainwald Charitable Foundation which will distribute monies to humanitarian organizations; Amnesty International and Médecins Sans Frontières (Doctors Without Borders). The publishers would like to thank all those who have made this project possible, including all the photographers, Magnum Photos, and Getty Images for donating the images, The Stinehour Press for printing, and Louise Fili Ltd for graphic design. ISBN# 0-345-39059-8

Text copyright © 1998 by J. Patrick Lewis. Illustrations copyright © 1998 by Gary Kelley. All rights reserved. No part of this publication may be reproduced or transmitted in any form or by any means, electronic or mechanical, including photocopy, recording, or any information storage and retrieval system, without permission in writing from the publisher. Requests for permission to make copies of any part of the work should be mailed to: Permissions Department, Harcourt Brace & Co., 6277 Sea Harbor Drive, Orlando, FL 32887-6777. *Creative Editions* is an imprint of The Creative Company, 123 South Broad Street, Mankato, Minnesota. 56001. Library of Congress Catalog Card Number: 98-8-4158. First Edition A C E F D B

COPYRIGHT © 1996 by W. Park Kerr. Photographs copyright © 1996 by Ellen Silverman. All rights reserved. No part of this book may be reproduced or utilized in any form or by any means, electronic or mechanical, including photocopying, recording, or by any information storage or retrieval system, without permission in writing from the Publisher. Inquiries should be addressed to Permissions Department, William Morrow and Company, Inc., 1350 Avenue of the Americas, New York, N.Y. 10019. It is the policy of William Morrow and Company, Inc., and its imprints and affiliates, recognizing the importance of preserving what has been written, to print the books we publish on acid-free paper, and we exert our best efforts to that end. Library of Congress Cataloging-in-Publication Data: Kerr, W. Park. Chiles / by W. Park Kerr. p.cm. ISBN 0-688-13251-0. 1. Cookery (Peppers) 2. Peppers. I. Title. TX803. P46K47 1996 641.6'384 —dc20 95-19031 CIP Printed in the USA. First Edition 1 2 3 4 5 6 7 8 9 10 Design Assistant: Tonya Hudson Book Design: Louise Fili Ltd.

229

POSTERS & POSTAGE

Although much of my inspiration comes from studying posters of the 1920s and 1930s from France and Italy, I have rarely had the opportunity to design one. For years, those posters that I did have the occasion to create were usually done free of charge, in exchange for creative freedom. While it is exhilarating to be asked to design something on a grand scale, with no brief and no caveats, this can also be quite unnerving. Creating a subway poster for SVA was the ultimate payoff. After close to thirty years of teaching at the school and admiring its many previous poster campaigns, I was finally given the chance to author my own. As thrilling as it was to view my design in subway stops all over New York City, to see it blown up three stories high was the utmost compliment. What could top that? A miniature poster design—a Love stamp for the U.S. Postal Service.

YOU

SVA MASTERS WORKSHOP

Roman holiday

———✳———

I enjoy creating this announcement each year almost as much as teaching in the program. As soon as the trip is over (or sometimes even before), I am already sketching next year's design.

Since 2009, I have been teaching every June at the SVA Masters Workshop in Venice and Rome, where I can share my enthusiasm for Italian food and typography with a group of fifteen participants. The program includes a visit to Tipoteca (the temple of letterpress), a private tour of the Roman Forum, and the chance to experience heart-stopping signage, gelato, and Prosecco along the way.

Each year affords a new opportunity to design a poster/mailer to attract new participants. The first year of the program, vintage luggage stickers provided inspiration. The next year I re-created mosaic floor tiles from Venice and other locales. The most recent iteration was drawn from my prized archive of Italian orange wrappers (of which I have hundreds—perhaps even thousands). It is no coincidence that the first thing I do with my students in Venice is to take them to fruit stands at the Rialto market to initiate their own collections.

SVA SUBWAY POSTER

Miles of tiles

———✳———

Over 8,400 tiles were assembled to create this poster. Photographed in various locations throughout the subway system, the tiles were painstakingly placed, one by one.

To catch someone's attention (legally) in the New York City subway is no easy feat. When Anthony Rhodes, executive vice president of SVA, invited me to design the latest in the school's esteemed series of subway posters, the only stipulations were from the MTA: "No adult images, vulgarity, transit-bashing (even if tongue in cheek), or text in a form that could be construed to be graffiti or promoting graffiti will be accepted." My initial idea was to do something with the classic, iconic mosaic tiles that are striking features of many different stations in the city. I was surprised to learn that no designer had ever referred to the subway or the mosaics in these posters. But the mosaic idea was just the beginning. For once, I had to come up with my own copy—a daunting task. I recalled George Eliot's "It's never too late to be who you might have been," and reinterpreted it to be more relevant to the setting. I presented four other directions with different copy lines, and we concurred that the mosaic idea was best. Then the nightmare began: creating the letters. It was imperative that, as in actual subway mosaics, no two letters be alike. Will my staff ever forgive me for the torturous month spent digitally creating this poster, one tile at a time? In the end, we all agreed that it might have been easier to have made it out of actual mosaic tiles. Nonetheless, it was a thrill to see it in situ, and to watch people touching it to see if the tiles were real. After a two-month run in the subway, the poster came aboveground as a thirty-eight-foot blowup on the side of the school building, where I can view it every day.

WHERE YOU'RE GOING

SCHOOL OF
VISUAL ARTS

① IT'S NEVER TOO LATE TO GET WHERE YOU'RE GOING
SCHOOL OF VISUAL ARTS

②

⑤

⑦

⑥ SVA.EDU
DESIGN BY LOUISE FILI LTD
©2011 VISUAL ARTS PRESS LTD

① *Initial sketch drawn on tracing paper* ② *A grid was constructed and a layout composed.* ③ *Letters were individually constructed from sample tiles.* ④ *Grout was meticulously laid in by hand using concrete texture for reference.* ⑤ *Arrow detail* ⑥ *Creating the poster credits out of mosaics was out of the question. The solution was a simulated brass plaque.* ⑦ *Outlines were created for each letter.* ⑧ *A finalized letter with completed background* ⑨ *The final resting place, on the northeast corner of Twenty-third Street and Third Avenue; the arrow happens to point to both SVA and my studio.*

More Posters

My first visit to Cincinnati was to judge a design competition in a beautiful art-deco building—in the basement—where no cappuccino was to be had. It became such a running joke that a year later, when the president of the art directors' club called to invite me to give a lecture, the first thing he said was, "Louise, we have cappuccino in Cincinnati now!" The poster that I designed for the event is a true artifact: not only is it pre-Photoshop, but it is also pre-Starbucks.

Now that espresso has come to Cincinnati, Louise Fili has left her cappuccino machine behind to venture west for an evening's engagement at the Art Directors Club of Cincinnati. Cincinnati Art Museum, September 20th.

For a lecture at Portfolio Center in Atlanta, I designed a poster that was inspired by a tiny powder box that I had found years before in a flea market in Milan.

Influenced by the work of French artist A.M. Cassandre, this poster/mailer was for a symposium of American design history at SVA.

A HISTORY OF AMERICAN GRAPHIC DES
MODE
MODE
ECLEC

SATURDAY, FEBRUARY 22ND & SUNDAY, F

N NUMBER FIVE • THE SCHOOL OF VISUAL ARTS

RNISM &
TICISM

RUARY 23RD, 1992 AT THE LOEWS SUMMIT HOTEL

In 1992 I was asked to design the cover of the AIGA annual. It was customary for AIGA, the professional association for design, not to give a brief, and I received no art direction. However, when I presented my concept to the director, I was told she had expected it to look like my "Modernism and Eclecticism" poster/mailer (page 240). Surprisingly, the cover was rejected for being "not American enough." The next year I recycled the design for the next "Modernism and Eclecticism" poster.

242

Modernism and Eclecticism

A HISTORY OF AMERICAN
GRAPHIC DESIGN SIX
SCHOOL OF VISUAL ARTS

The Goethe House in New York City commissioned me to design a poster for an exhibition of the avant-garde German publisher Malik Verlag, whose striking book jackets were created by photomontage artist John Heartfield.

MALIK VERLAG

AN EXHIBITION OF BOOKS, PORTFOLIOS & PERIODICALS OF THE MALIK-VERLAG, BERLIN·PRAGUE·NEW YORK 1916·1947

ORGANIZED BY JAMES FRASER AND STEVEN HELLER

AT THE GOETHE HOUSE, 1014 FIFTH AVENUE, NYC 25 SEPTEMBER·20 OCTOBER 1984

FUNDED IN PART BY THE SWANN FOUNDATION FOR CARICATURE AND CARTOON IN ASSOCIATION WITH THE MADISON CAMPUS LIBRARY·FAIRLEIGH DICKINSON UNIVERSITY DESIGN LOUISE FILI

SOCIETY OF PUBLICATION DESIGNERS

CALL
FOR ENTRIES

YOU ARE INVITED
TO PARTICIPATE
IN THE S·P·D·
20ᵀᴴ ANNUAL
COMPETITION
CELEBRATING
EXCELLENCE
IN PUBLI-
CATION
DESIGN

ALL ENTRIES
MUST BE
RECEIVED
BY JAN.
30ᵀᴴ
1985

This call for entries for the Society of Publication Designers fulfilled one of my life-long ambitions—to design an eye chart.

245

U.S. POSTAL SERVICE

Love letters

———✻———

I enjoyed the added challenge of having to think of this stamp as both a single unit and as part of a repeat pattern on a sheet.

I HAVE ALWAYS ADMIRED THE DESIGN OF POSTAGE STAMPS. EVERY ASPECT of a stamp—the fine detail and reproduction, minuscule proportion, delicate colors, perforation, and tactile quality—is irresistible. Not every designer gets the opportunity to create a U.S. postage stamp. It is a distinct honor to which I had never considered aspiring until Jessica Helfand, one of the design consultants on the Postmaster General's Citizens' Stamp Advisory Committee, invited me to design a Love stamp. This series of U.S. Postal Service stamps has an impressive history, beginning with Robert Indiana's serigraph *Love*, which was issued as a stamp in 1973. Like all great assignments, it was both thrilling and terrifying. How could I design something so small, for a subject so large? Was it possible that there existed a concept for love that hadn't already been used? There wasn't even time to panic; I was on a tight deadline. I thought of the stamps as mini-posters and started sketching typographic treatments. My first idea was to create the word out of flowing ribbons. I presented that direction, along with two other concepts (which I am forbidden to divulge). Fortuitously, it was made into a Forever stamp, so I hope to see it around for a long, long time. At 1.2 inches by .9 inches and 250 million impressions, the Love stamp most certainly has the smallest trim size of anything I have ever designed, and the largest print run.

forever

Love

USA 2012

forever

CREDITS

page 13
Photograph: Henry Leutwyler

BOOKS
pages 18–25

Pantheon Books
pages 18–23
All book covers art directed and designed by Louise Fili.

page 19
The Lover, 1985
Lettering: Craig DeCamps

page 20
Top row:
WPA Guides, 1982
Illustrations: John Martinez

Center row:
Pantheon Modern Classics, 1982
Illustrations: Dagmar Frinta
Lettering: Louise Fili

Bottom row:
Kafka series, 1988
Illustrations: Anthony Russo

page 21
The War, 1986

Annie Leibovitz: Photographs, 1983
Photograph: Annie Leibovitz

Light, 1983
Painting: Claude Monet

The Artful Egg, 1985
Illustration: Robert Goldstrom

Perfect Gallows, 1987
Illustration: Robert Goldstrom

Latecomers, 1988
Illustration: Barbara Nessim

London in the Thirties, 1984
Photograph: Bill Brandt

African Folktales, 1983
Illustration: Bascove

The City, 1988
Illustration: Frans Masereel

Franz Kafka, 1984

Maus, 1986
Illustration: Art Spiegelman

Blue Eyes, Black Hair, 1987
Illustration: Craig DeCamps

page 22
Arab Folktales, 1986
Illustration: Melanie Parks

The Victorian Fairy Tale Book, 1988
Illustration: John Craig

Russian Fairy Tales, 1982
Illustration: Beatrice Fassell

Japanese Tales, 1987
Illustration: Melanie Parks

The Innocence of Dreams, 1979
Photograph: Serge Luytens

The Genius of the System, 1989

When Things of the Spirit Come First, 1982

Dear Diego, 1986
Illustration: Craig DeCamps

Archipelago, 1989
Illustration: Robert Goldstrom

Flywheel, Shyster, and Flywheel, 1989
Illustration: Bill Nelson

The Seven Ages, 1986
Illustration: Dugald Stermer

Once in Europa,
Illustration: Dugald Stermer

Pantheon Books Catalog Covers
page 23

Fall 1982
Illustration: John Martinez

Spring 1984
Illustration: Jackie Chwast

Spring 1986
Illustration: Philippe Weisbecker

Fall 1985
Illustration: Dave Calver

Spring 1989
Illustration: Robert Goldstrom

Fall 1986
Illustration: Steven Guarnaccia

Spring 1987
Illustration: Dugald Stermer

Spring 1985
Illustration: Pierre Le-Tan

Fall 1980
Illustration: Ed Koren

Fall 1983
Illustration: Ed Koren

Fall 1981
Illustration: Daniel Pelavin

Beyond Pantheon
pages 24–25
All book covers designed by Louise Fili.

The Bourgeois Experience, 1984
Oxford University Press

Julia Paradise, 1989
Simon and Schuster

Italian Days, 1989
Grove Weidenfeld

Freud's Vienna, 1991
Vintage

Whitman's Wild Children, 1999
Steerforth Press

Women in a River Landscape, 1988
Alfred A. Knopf

The Company They Kept, 2009
New York Review Books

African Laughter, 1993
Harper Perennial

Paris Was Yesterday, 1988
Harcourt Brace Jovanovich

Poem a Day, 1998
Steerforth Press

My Mexico, 1998
Clarkson Potter

Madame du Barry, 1992
Grove Weidenfeld

Piazza Carignano, 1986
Atlantic Monthly Press

Rainer Maria Rilke: New Poems, 2001
Farrar, Straus and Giroux

William Burroughs, 1994
Hyperion

The Book of Images, 1994
Farrar, Straus and Giroux

Penelope's Hat, 1991
Simon and Schuster
Photograph: Marcia Lippman

The Divine Sarah, 1991
Alfred A. Knopf

Italian Folktales, 1981
Harcourt Brace Jovanovich

Sexual Personae, 1991
Vintage

The Ambassador, 1980
Simon and Schuster

The City of Florence, 1994
Farrar, Straus and Giroux
Photograph: Marcia Lippman

Louise Brooks, 1989
Alfred A. Knopf

248

RESTAURANTS
pages 26–75

Picholine, 1993
Design: Louise Fili and
Mary Jane Callister
Illustration: Melanie Parks

The Pink Door, 1998
Design: Louise Fili and
Mary Jane Callister

Marseille, 2001
Design: Louise Fili

Monzù, 1997
Design: Louise Fili and
Mary Jane Callister
Illustration: Lars Leetaru

Union Pacific, 1998
Design: Louise Fili and
Mary Jane Callister

Metro Grill, 1997
Design: Louise Fili and
Mary Jane Callister

The Mermaid Inn, 2003
Mermaid Oyster Bar, 2010
Design: Louise Fili and
Chad Roberts
Illustration: Anthony Russo

Artisanal, 2001
Design: Louise Fili and
Mary Jane Callister
Illustration: Christopher Wormell

Sfoglia, 2006
Design: Louise Fili
Illustration: Lars Leetaru

Bedford Post, 2008
Design: Louise Fili and
Jessica Hische
Illustration: Mark Summers
Photograph: courtesy of
Richard Gere

Bolivar, 1998
Design: Louise Fili and
Mary Jane Callister

Métrazur, 1998
Design: Louise Fili and
Mary Jane Callister

92, 2001
Design: Louise Fili
Illustration: Mirko Ilić

Txikito, 2008
Design: Louise Fili and
Jessica Hische

Pace, 2004
Design: Louise Fili

The Screening Room, 1998
Design: Louise Fili
Photography: William Duke

Roseville, 2008
Design: Louise Fili and
Jessica Hische

Candle Cafe, 1994, 2008
Design: Louise Fili

Civetta, 2009
Design: Louise Fili and
Jessica Hische
Illustration: Jessica Hische

PACKAGING
pages 76–125

Bella Cucina, 1995–present
Design: Louise Fili

Jean-Georges, 1998
Design: Louise Fili and
Mary Jane Callister

Sarabeth's, 2005
Design: Louise Fili

Late July, 2003
Design: Louise Fili and
Chad Roberts
Illustration: Graham Evernden

Tate's, 2002
Design: Louise Fili and
Chad Roberts

El Paso Chile Company
pages 92–95

BBQ series, 2003
Design: Louise Fili and
Chad Roberts

Margarita Mix, 1998
Design: Louise Fili and
Mary Jane Callister
Illustration: James Grashow

Irving Farm Coffee Company,
2004, 2009
2004: Design: Louise Fili and
Chad Roberts
2009: Design: Louise Fili and
Jessica Hische

American Spoon, 2006
Design: Louise Fili
Illustrations (labels):
Charlotte Knox
Illustration (logo):
Christopher Wormell

L'Arte del Gelato, 2009
Design: Louise Fili and
Jessica Hische

Big Island Bees, 2006
Design: Louise Fili
Illustrations: Dugald Stermer

Q.bel, 2008
Design: Louise Fili and
Jessica Hische
Illustrations: Ben Garvie

Il Mulino, 2003
Design: Louise Fili and
Chad Roberts

Wines
pages 114–119

Sfida, 2000
Design: Louise Fili and
Mary Jane Callister

Bosco del Grillo, 2008
Design: Louise Fili and
Jessica Hische

Terrazzo Prosecco, 2008
Design: Louise Fili and
Jessica Hische

Il Conte, 2008, 2009
Design: Louise Fili and
Jessica Hische

Tratturi, 2009
Design: Louise Fili and
Jessica Hische

Calea, 2008, 2009
Design: Louise Fili and
Jessica Hische

Bartlett, 1995
Design: Louise Fili

Blue Q
pages 120–125

Italiano mug, 2011
Design: Louise Fili and
John Passafiume

Alpha Shopper, 2008
Design: Louise Fili

da Vinci tote, 2010
Design: Louise Fili and
John Passafiume

da Vinci pouch, 2010
Design: Louise Fili and
John Passafiume

World Shopper, 2006
Design: Louise Fili

Madonna Shopper, 2008
Design: Louise Fili and
Jessica Hische

Perfume Shopper, 2008
Design: Louise Fili and
Jessica Hische

IDENTITIES
pages 126–181

Tiffany & Co., 2005
Design: Louise Fili and
Chad Roberts

Ilux, 2000
Design: Louise Fili

Hanky Panky, 2001
Design: Louise Fili

Paul Tanners, DDS, 2007
Design: Louise Fili and
Jessica Hische

Grassroots, 1996
Design: Louise Fili and
Mary Jane Callister
Illustration: Fiona King
Photograph: Paul Warchol

Rusk Renovations, 2007
Design: Louise Fili and
Jessica Hische

Crane & Co., 2011
Design: Louise Fili and
John Passafiume

Le Monde, 1999
French bistro
Design: Louise Fili

Pigalle, 2000
French restaurant
Design: Louise Fili

Ombra, 2002
Italian restaurant
Design: Louise Fili

Metro Marché, 2006
French restaurant
Design: Louise Fili and
Chad Roberts

Ecco, 2000
Publisher
Design: Louise Fili

Maritime, 2000
Seafood restaurant
Design: Louise Fili and
Mary Jane Callister

Metropole, 1999
French restaurant
Design: Louise Fili

Crawford Doyle Booksellers, 1997
Design: Louise Fili
Illustration: Anthony Russo

Au Café, 1992
Design: Louise Fili
Illustration: Steven Guarnaccia

Conte's, 2002
Design: Louise Fili and
Chad Roberts

The Harrison, 2001
Design: Louise Fili and
Mary Jane Callister

Malama, 2000
Design: Louise Fili and
Mary Jane Callister

The Gables, 2003
Design: Louise Fili and
Chad Roberts

Risi Bisi, 2001
Design: Louise Fili

Cibi Cibi, 1998
Design: Louise Fili and
Mary Jane Callister

Specchio, 2001
Design: Louise Fili

Maison, 2000
Design: Louise Fili

Belli, 2007
Design: Louise Fili and
Jessica Hische

Aura, 2008
Design: Louise Fili and
Jessica Hische

Delamar, 2001
Design: Louise Fili

Biella, 1998
Design: Louise Fili and
Mary Jane Callister

Hyperion, 1989
Design: Louise Fili

Honolulu Coffee Company, 1998
Illustration: Gary Kelley
Design: Louise Fili and
Mary Jane Callister

Vandenberg, 2005
Design: Louise Fili and
Chad Roberts

Calabria, 1998
Design: Louise Fili and
Mary Jane Callister

Tocqueville, 2005
Design: Louise Fili

Blount Park, 1999
Design: Louise Fili and
Mary Jane Callister

Aventino, 2008
Design: Louise Fili and
Jessica Hische

Rive Gauche, 1999
Design: Louise Fili

Before and After
pages 168–181

Good Housekeeping, 2008
Design: Louise Fili and
Jessica Hische

Sarabeth's, 2005
Design: Louise Fili

Hanky Panky, 2001
Design: Louise Fili

Manhattan Fruitier, 1998
Fruit-basket delivery service
Design: Louise Fili and
Mary Jane Callister

American Spoon, 2006
Design: Louise Fili
Illustration: Christopher Wormell

Dufour, 2002
Frozen puff pastry maker
Design: Louise Fili and
Chad Roberts
Illustration: Melanie Parks

L'Arte del Gelato, 2009
Design: Louise Fili and
Jessica Hische

Irving Farm, 2004
Design: Louise Fili and
Chad Roberts

Il Mulino, 2004
Design: Louise Fili and
Chad Roberts

Aqua Forté, 2008
Fluoridated water
Design: Louise Fili and
Jessica Hische

Bonnie's Jams, 2011
Artisanal-jam producer
Design: Louise Fili and
John Passafiume

Bespoke Education, 2007
Tutoring service
Design: Louise Fili

Bella Cucina, 1995
Design: Louise Fili and
Mary Jane Callister
Illustration: Jeff Crosby

DESIGNER/ AUTHOR
pages 182–229

Euro Deco, 2005
Design: Louise Fili

British Modern, 1998
Design: Louise Fili

French Modern, 1996
Design: Louise Fili

German Modern, 1998
Design: Louise Fili

Deco Type, 1997
Design: Louise Fili

Italian Art Deco, 1993
Design: Louise Fili

Dutch Moderne, 1994
Design: Louise Fili

Deco España, 1997
Design: Louise Fili

Streamline, 1995
Design: Louise Fili

Design Connoisseur, 2000
Design: Louise Fili

Typology, 1999
Design: Louise Fili

Stylepedia, 2006
Design: Louise Fili and
Chad Roberts

Cover Story, 1996
Design: Louise Fili

Counter Culture, 2005
Design: Louise Fili
Photographs: Tony Cenicola

Scripts, 2011
Cover design: Louise Fili
and John Passafiume
Interior design: Jessica Hische, John Passafiume, and Dana Tanamachi

Logos A to Z, 1997–2002
Design: Louise Fili

A Designer's Guide to Italy, 2002
Design: Louise Fili and Mary Jane Callister

The Civilized Shopper's Guide to Florence, 2007
Design: Louise Fili

Italianissimo, 2008
Design: Louise Fili and Jessica Hische

Rizzoli Italian novels series, 2011
Design: Louise Fili and John Passafiume

SVA Senior Library, 2011
Creative Director: Anthony Rhodes
Cover design: Louise Fili and John Passafiume
Interior design: John Passafiume and Dana Tanamachi

The Little Bookroom
pages 218–223

Sew Chic, 2004
Design: Louise Fili and Rebecca Bartlett

The Patisseries of Paris, 2007
Design: Louise Fili and Jessica Hische

The Bars, Cafés and Restaurants of Buenos Aires, 2007
Design: Louise Fili and Jessica Hische

The Traditional Shops & Restaurants of London, 2008
Design: Louise Fili and Chad Roberts

Savoir Fare London, 2008
Design: Louise Fili and Jessica Hische

Shopping in Marrakech, 2009
Design: Louise Fili and Jessica Hische

Paris Chic & Trendy, 2008
Design: Louise Fili and Jessica Hische

The Authentic Bistros of Paris, 2005
Design: Louise Fili and Chad Roberts

Back Lane Wineries of Sonoma, 2009
Design: Louise Fili and Jessica Hische

Chic Shopping Paris, 2008
Design: Louise Fili and Jessica Hische

Terroir Series:
Food Wine: The Italian Riviera & Genoa, 2008
Food Wine: Budapest, 2008
Design: Louise Fili and Jessica Hische

Civilized Shopper Series:
The Civilized Shopper's Guide to Florence, 2007
The Curious Shopper's Guide to New York City, 2006
The Civilized Shopper's Guide to Rome, 2004
Design: Louise Fili

Copyright Pages
pages 224–229
All designed by Louise Fili.

Lost Words of Love, 1993
Clarkson N. Potter

Gardener's Latin, 1992
Algonquin Books

The Best Tea Places in England, 2002
The Little Bookroom

Beans, 1996
William Morrow

The Wild Party, 1994
Pantheon Books

Aperitif, 1997
Chronicle Books

You Can't Be Too Careful, 1992
Algonquin Books

A Great and Glorious Game, 1998
Algonquin Books

Sarabeth's Bakery, 2010
Rizzoli

Death of Medicine, 1998
Ardor Scribendi

Writing New York, 1998
Library of America

Historic Restaurants of Paris, 2001
Little Bookroom

The Twin Towers, 2001
Picture This Publications

Boshblobberbosh, 1998
Creative Editions

Chiles, 1996
William Morrow

POSTERS & POSTAGE
pages 230–247

SVA Masters Workshop in Italy, 2008, 2009, 2010
2008: Design: Louise Fili and Jessica Hische
2009: Design: Louise Fili
2010: Design: Louise Fili and John Passafiume

SVA Subway Poster, 2011
Creative Director: Anthony Rhodes
Design: Louise Fili, John Passafiume, and Dana Tanamachi

Cincinnati poster, 1994
Design: Louise Fili
Photograph: Ed Spiro

Portfolio Center poster, 1995
Design: Louise Fili and Mary Jane Callister

Modernism and Eclecticism poster/mailer, 1992
Design: Louise Fili

Graphic Design USA, 1992
Design: Louise Fili
Photograph: David Barry

Modernism and Eclecticism poster, 1993
Design: Louise Fili
Photograph: David Barry

Malik Verlag poster, 1984
Design: Louise Fili
Photograph: John Heartfield

Society of Publication Designers poster, 1985
Design: Louise Fili

U.S. Postal Service Love stamp, 2012
Design: Louise Fili and Jessica Hische

page 252
Photograph: Annie Schlecter

ACKNOWLEDGMENTS

My career has been enriched by so many colleagues, clients, employees, mentors, students, family members, and friends. This book is dedicated to all of you.

I would like to express my thanks to Mirko Ilić and Matteo Bologna for their early and persistent encouragement, which sparked the beginnings of this project.

Likewise, deepest thanks to the staff at Princeton Architectural Press, who made this book a reality: editorial director Jennifer Lippert, my editor Nicola Bednarek Brower, and publisher Kevin C. Lippert.

Thank you to my former employers for their roles in advancing my work: Herb Lubalin, Bob Scudellari, and André Schiffrin.

I am most indebted to John Passafiume and Dana Tanamachi at Louise Fili Ltd for their masterful and devoted design work on this book, and to my colleague and friend Wendy Wolf, for her invaluable editorial insights.

This book would not have been possible without all the clients who have given me the opportunity to work on so many wonderful projects: Danny Abrams, Alisa Barry, Robert and Kathe Bartlett, Roberto Bellissimo, Sondra and Steve Beninati, Red Blount, Jimmy Bradley, Terrance Brennan, Ottavio Brizzi, Heather Carlucci-Rodriguez, Robert Cole, Richard Coraine, Judy Crawford, Peter Crippen, Nicole Dawes, Rocco DiSpirito, John Doyle, David Elwell, Gale Epstein, Cindy and Mike Figer, Tina Fischer, Richard Gere, Jehv Gold, Whendi and Phil Grad, Allan Greenberg, Angela and Rea Hederman, Peter Hoffman, Anil Jagtiani, Park Kerr, Kathleen King, Mary Kocy, Noel Labat-Comess, Steve Leven, Tim Levin, Sarabeth and Bill Levine, Harris Lewine, Michael Lomonaco, Carey Lowell, Noah Marshall-Rashid, Peter Matt, Frank Metz, Danny Meyer, Mike and Karen Miele, Eder Montero, Mitch Nash, Simon Oren, Lida Orzeck, Joy Pierson and Bart Potenza, Doug Polaner, Alex Raij, Justin Rashid, Francesco Realmuto, Adam Riess, Jackie Roberts, Susan Rosenfeld, John Rusk, Marcus Samuelsson, Elisabeth Scharlatt, Renee Shaw, Bonnie Shershow, Bahram Shirazi, Karen Silveira, Andrew Silverman, Krystyna Skalski, Ron Suhanosky, Paul Tanners, Steve Tenedios, Phil Teverow, and Jean-Georges Vongerichten.

To my enormously talented staff, past and present, my sincere appreciation for tireless attention to detail: Rebecca Bartlett, Lee Bearson, Jennifer Blanco, Mary

Jane Callister, Spencer Charles, Andrew Evans, Lesley Hathaway, Jessica Hische, Tonya Hudson, Melissa Jun, Abbey Kuster-Prokell, Leah Lococo, Elizabeth Morrow-McKenzie, John Passafiume, Chad Roberts, Mahsa Safati, Dana Tanamachi, Irene Vandervoort, Miranda Verouli, Courtney Waddell, and Michelle Willems.

School of Visual Arts has been a unique source of inspiration for me, as both a student and teacher, for close to thirty years. A heartfelt thank-you to David Rhodes, president; Anthony Rhodes, executive vice president; Richard Wilde, chair, BFA graphic design and advertising; Carolyn Hinkson-Jenkins, curriculum coordinator; and Michael Walsh, Visual Arts Press.

A designer is nothing without great collaborators. I am indebted to the exceptional illustrators, photographers, designers, architects, writers, retouchers, and printers who have contributed to the work in this book: Lise Apatoff, Warren Ashworth, Quentin Bacon, Bascove, Larry Bogdanow, Dave Calver, Tony Cenicola, Emily Cohen, Mike Cohen, Diane Cook, Jeff Crosby, Craig DeCamps, Tom Engelhardt, Graham Evernden, Dagmar Frinta, Tony Garcia, Ben Garvie, Robert Goldstrom, James Grashow, Steven Guarnaccia, Jonathan Hoefler, Deborah Jones, Jerry Kelly, Katherine Kleinman, Charlotte Knox, Viktor Koen, Lars Leetaru, Pierre Le-Tan, Henry Leutwyler, Vicki Gold Levi, Liney Li, Marcia Lippman, Lou Manna, Russell Maret, John Martinez, Bill Nelson, Barbara Nessim, Derry Noyes, Melanie Parks, Daniel Pelavin, Jane Rosch, Anthony Russo, Annie Schlechter, Susan Simon, Dugald Stermer, Mark Summers, Edwina Von Gal, Paul Warchol, Philippe Weisbecker, Ralph Wernli, and Christopher Wormell.

Thank you to the colleagues and friends who have so generously supported me throughout the years: Gail Anderson, Marshall Arisman, Ed Benguiat, Fern Berman, R.O. Blechman, Ann Bramson, Seymour Chwast, James Clough, Pietro Corraini, Gina Davis, Stephen Doyle, Milton Glaser, Robbin Gourley, Bob Grossman, Kate Hanenberg, Jessica Helfand, Dee Ito, Nancy Kaufman, Moisha Kubinyi, Elaine Louie, David Lowenherz, Midge MacKenzie, Rosella Matt, Faith Middleton, Susan Mitchell, Douglas Riccardi, Barbara Richer, Paula Scher, Sara Slavin, Art Spiegelman, Stephanie Tevonian, Gael Towey, and Mauro Zennaro.

Lastly, and most importantly, my eternal gratitude and love to my family, Steven Heller and Nicolas Heller, who have taught me everything I know.

Chicken or fish?

I WAS ONCE ON MY WAY BACK FROM ITALY VIA PARIS, WHERE MY connecting flight was hopelessly delayed. With too much time and too many cappuccinos, I had been reflecting on the meaning of life, thinking, "So I've done some nice book jackets and logos, but I've never saved a life doing that." By the time we finally boarded, everyone was on a short fuse, particularly the crew. Soon after takeoff, an attendant came around with the dinner service and rudely blurted out her question: "Chicken or fish?" The young man seated next to me, of undetermined ethnic origin, stared at her blankly. She eyed him and asked, *"Français? Italien?"* Continued blank stare. I jumped in, offering other options. Finally, he brightened, and triumphantly exclaimed, *"Ruskie!"* The attendant tossed him a menu—in English and French—and started to walk away. I realized that if I didn't step in and do something, this poor man would starve! I whipped out a pen, grabbed the menu, and drew this:

Young Vladimir opted for the chicken. And I found the validation I was seeking: through graphic design, I had kept someone from going hungry.